Ayurveda

the ultimate medicine

Ayurveda
the ultimate medicine

Dr S.C.Sharma

wisdom
tree

ISBN 81-86685-66-9

Published by
Wisdom Tree
C-209/1, Mayapuri II,
New Delhi 110 064
Ph.: 28111720, 28114437

Published by *Shobit Arya* for Wisdom Tree; Edited by *Manju Gupta*; Designed by *Kamal P. Jammual*; Typeset at Icon Printographics, New Delhi-18 and printed at Print Perfect, New Delhi-64.

Nothing in the world is so powerful as an idea whose time has come.

—VICTOR HUGO

CONTENTS

PREFACE

Āyurveda, the mother of all medical systems, proves right the adage 'old is gold'. Shining bright after centuries of use, it is as relevant today as it was more than 5,000 years ago. Āyurveda is the knowledge and experience of many centuries put together in the form of aphorisms, couplets and formulae. It does not emphasise on fighting specific diseases as such but focuses on the well-being of the whole system, and helps to develop total good health.

I have put in over four decades of work in practising, researching and studying this science, and I feel I should make this ancient science more accessible to the new generation. This is what I have tried to do through this book. I have focused on giving an overview of the science without laying too much stress on its philosophy and other details. This book is also an invitation to future generations of scientists, bio-technologists and geneticists to work on Āyurveda for universal benefit.

Professional peers and colleagues, experts and pharma-ceutical developers have been consulted while writing this book. This book is intended for people of all ages, countries, religions, professions and interests. If the readers have queries, they are most welcome to write to me.

ACKNOWLEDGEMENT

I hope and pray that this book introduces you to what I consider to be the ultimate in medicine, Āyurveda.

I am indebted to Dr Hitendra Ahuja and his father, Dr T. N. Ahuja, both senior ophthalmologists, for acting as catalysts in the writing of this book. This book would never have been completed without the ideas shared with them over the last one decade.

I thank Shri Ravindra Kumar, Chairman and Shri Rajiv Kumar, Managing Director of the Dharampal Satyapal Group, who gave me the opportunity to learn complex principles of Āyurveda while working under Mrs Navneet Kaur, Director of their Research and Development wing. Her inspiring encouragement provided the much-needed technical and scientific support.

I t is a great pleasure that this book introduces with...
... consider it the essential support for...
... interested to the theories about ... first, the
... it. With the consent and willingness of ... there is
... to the writing of this book. This work would never
... become a complete textbook on ... we simply wish for
... the last one itself.

I thank Shri Ramdev to their valuable help for ...
... to our disappointment to ... of the ... journal ...
... who worked the appointment in their course
... might of their health and so ... on the ... years
... and director of their side and ... their ... among
... the institute in ... of the right time and
... and our ... and ... before.

1

THE BEGINNING

Ultimate Reality or God is one. This one truth has been repeatedly pronounced through all ages and continues to be done so, by learned men across the globe, in different styles at different times to different people in different regions. This is the truth believed in by people of all races.

Similarly, in medical science too, despite the many branches, it is said that there is one ultimate medical system from which every other system arises. This ultimate medicine system is Āyurveda. While biology and modern medical science deal with the knowledge and remedies of specific discases, Āyurveda deals with every aspect of life — *dharma* (essential duties as per status or position), *artha* (wealth or goals), *karma* (actions and obligations), and *mokṣa* (liberation from every bondage). Āyurveda thus looks into the holistic well-being of individuals and global societies.

THE CREATION OF ĀYURVEDA

Caraka Saṁhitā, the oldest medical text in the world, tells us of the orgins of Āyurveda. Brahmā, the creator, taught the

science to his son, Dakṣa Prajāpati. Dakṣa further taught the science to the divine physicians, the Aśvinī Kumāras. Indra, the king of heaven, conceived this knowledge from the Aśvinī Kumāras.

Meanwhile, living beings were suffering from fatal diseases, despite practising yoga and performing all kinds of religious rites. Ṛṣi Bharadwāja, representing a galaxy of savants, saints and scholars in their respective disciplines of knowledge, approached Indra for the cure. Indra granted him special favour and taught him the science and philosophy of Āyurveda in a brief and concise discourse. The lessons were related to three aphorisms, namely *hetu* (cause), *liṅga* (signs and symptoms) and *auṣadha* (drugs) of health and disease. These are eternal and significant principles of health and disease.

Bharadwāja passed on this knowledge to Ātreya, who in turn passed it on to his disciples, Agniveśa, Bhela, Parāśara, Kṣārapāni, Jatūkarṇa and Hārīta. Each of Ātreya's disciples wrote down his own commentary, and thus came about Āyurveda or the 'wisdom of life'. This was the first integration of spiritualism with material and medical sciences.

The sages evolved the tenets of *sāmānya* (similarity), *viśeṣa* (particularity), *guṇa* (quality), *dravya* (substance), *karma* (action) and *samavāya* (concomitant cause) for avoiding causes of death. They defined Āyurveda as a treatise dealing with the wholesome and unwholesome, happy as well as unhappy, qualitative and the quantitative aspects of life. Āyurveda was never a purely medical science; it was developed as a science of ways of living and the life itself.

BRANCHES OF ĀYURVEDA

Based on the writings of the disciples of Ātreya, Āyurveda is seen to cover eight disciplines, also called Aṣṭaṅga Āyurveda. These are:

- *Kāya cikitsā:* Internal general medicine. It deals with the management of most illnesses.

- *Śalya tantra:* Surgery. There is a separate treatise named *Suśruta Saṁhitā*.
- *Śālākya tantra:* Ear-nose-throat and ophthalmology. It prescribes treatment of diseases of head, neck, ear, nose, throat, teeth and eyes.
- *Agada tantra:* Toxicology and its allied subjects.
- *Bhūta vidyā:* Psychiatry; management of mental diseases.
- *Kaumārabhṛtyam:* Paediatrics or diseases of children.
- *Rasāyana tantra:* Geriatrics, including rejuvenation therapy.
- *Vājīkārṇa tantra:* Sexology and the science of aphrodisiacs.

There are other neo-branches such as:

Pañcakārma cikitsā: Physiotherapy and five eliminative measures.

Prasūti tantra and Stri roga śāstra: Obstetrics and gynaecology.

Mānasika roga śāstra: Psychiatry or psychotherapy.

Pathyāpathya: Dietary management.

Dravya guṇa vijñāna: Botanicals and herbal medicine.

Rasa-śāstra and bhaiṣajya kalpanā: Pharmaceuticals and drugs.

Yoga: Meditation and exercise.

Agni vyāpāra: Bio-energetic manipulation.

Important space is given to epidemiology. Āyurveda came about as a science at a time when spiritualism and yogic technologies failed to stop the spread of ill health and diseases and epidemics were widespread. Causes of diseases, signs and symptoms and drugs to restrict their spread were thus learnt through a scientific methodology. In this endeavour, the original concepts of spiritualism were not discarded but epidemiology gained equal importance. This resulted in the holistic and integrated approach of Āyurveda.

BASICS OF ĀYURVEDA

According to Āyurveda, life span is related to a balanced union

of the body, organs, mind and soul. The individual is a microtome of the universe, and is made up of nine basic substances — the *pañcamahābhūtas* (i.e. the five primordial elements that include air, water, ether, fire and earth), *ātma* (soul), *manaḥ* (mind), *kāla* (time) and *diśā* (direction).

There are two types of diseases — psychic diseases (of the mind) and somatic diseases (of the body). According to Āyurveda, the entities responsible for diseases due to non-union, excessive union, false union, and improper union of *kāla* (time), *buddhi* (reasoning) and *indrayārthas* (objects of sensory and motor organs). However, diseases will also occur if there is no union between the three. Happiness and health are achieved when these three entities are united in a correct and balanced proportion.

There is a clear influence of integration of mysticism with rational treatment in Āyurveda. Āyurveda is also of the view that the soul is not affected by happiness or unhappiness. It is only an eyewitness to the happenings.

Diseases of the body are kept under control by (a) *daivyapāśraya* and (b) *yuktivyapāśraya*. *Daivyapāśraya* includes sacrifices, auspicious rites, observance of good conduct, etc. while *yuktivyapāśraya* involves the rational prescription of drugs.

For diseases of the mind, the treatment consists of:
- *Jñāna* (knowledge)
- *Vijñāna* (science)
- *Dhairya* (patience)
- *Smṛti* (remembrance)
- *Samādhi* (concentrated presence before the truth), etc.

ELEMENTS OF ĀYURVEDA

In Āyurveda there is a constant reference to certain elements. It is important to be clear about these elements and understand what they refer to. The main elements, which need to be explained at the very beginning are the *pañcamahā-bhūtas*, *kāla*, *doṣā*, and *guṇā*. These would be explained again in the various chapters as necessary.

Kāla

Time or *kāla* is dealt in a very pragmatic way. Time moves in a continuous flow. No matter whether time moves or events move over time, continuous change is inevitable. Every second, the present is continuosly moving into the future, while the present moment becomes your past. You are reading this sentence in the present but with every passing moment, your present is changing into past and you are another step into your future. In other words, 'is' exists but for a second when a new 'is' replaces it. Continuity and habit make us perceive 'is' as 'is' when technically it should be 'was'.

Time is also related to evolution. According to Āyurvedic texts, the universe evolved from a vacuum with a big sound (*śabda*), then evolved space (*ākāśa*), air (*vāyu*), fire (*agni*), water (*jala*), and finally earth (*pṛthvī*). The details of the process of evolution as explained in Āyurveda can form a seperate book in itself.

Pañcamahābhūtas

The five primordial elements, namely *akāśa* (space), *vāyu* (air), *agni* (fire), *jala* (water) and *pṛthvī* (earth) are called the *pañcamahābhūtas*. Every substance in the universe is made up of these substances in different proportions.

Doṣā

Doṣās are the functional projections of the *pañcamahābhūtas*. There are three doṣās, each with its own significances:

(a) *Vāta:* This represents air and space and has attributes like dryness, roughness, coolness, lightness, fineness, mobility, and porosity.

(b) *Pitta:* This represents agni (fire) and has the attributes of unctuousness, heat, sharpness, liquidity, salty to taste, slowness, and pungency.

(c) *Kapha:* This represents *jala* (water) and *pṛthvī* (earth) and has the attributes of heaviness, coolness, tenderness, unctuousness, sweetness, stability and smoothness.

Doṣās are faults as well as positive forces. They aid in good actions but also vitiate elements.

Guṇā

The mind has got three types of attributes or *guṇās* — *sattva*, *rajaḥ* and *tamaḥ*. Among these three projections of the mind, only two are analysed under *doṣās* — *rajaḥ* and *tamaḥ*. Sattva is only concerned with good actions and functions, and so is not studied under malevolent nature of *doṣā*.

ĀYURVEDIC TRAINING, PRACTICE AND STUDIES

Training

Education is known as *jñāna mārga* or the path of knowledge. In ancient India, there were eminent centres of learning such as Takśasilā, Nālandā, Vikramaśila, Mithila, Kāśī, etc., which were very famous throughout the world.

Perhaps, the most famous medical school was the one attached to the University of Takśasilā, in the north-west of India. It was near what is now called Rawalpindi, in Pakistan. Several historical records exist about this school, and scientists like Brahmadatta, Pāṇini, Nāgarjuna and Jīvaka were attached to it.

Two other well-known universities were located in northern India: Nālandā, near the present-day Bihar, and Kāśī, now called Vārāṇasī. Students came from distant countries to study in these universities. While the study of Āyurveda was compulsory in Nālandā, which flourished from the 5th to the 12th centuries, Kāśī specialised in surgery.

Eminent authorities who made efforts to write extensive commentaries on the three main classics: *Caraka Saṁhitā, Suśruta Saṁhitā, Aṣṭaṅga Saṅgraha* were Cakrapani Datta, Indu, Hemādri and Arunadhatta. Madhava, Śāraṅgadhara and Bhāva Miśra added new ideas and experiences of their period through their works *Mādhava Nidāna* (AD 700), *Śāraṅgadhara Saṁhitā* (AD 1226) and *Bhāva Prakāśa* (AD 1558) respectively.

As the global society changed and spiritual ideals were

replaced by materialism, developments in the field of Āyurveda ceased. Instruments and devices prescribed by Āyurveda, which were capable of being used to harm the body, were banned and discarded. This resulted in the decline of surgery and only internal medicine (*kāya cikitsā*) survived. All the centres of learning got destroyed in the course of time. Knowledge got imparted through secret discourses to select individuals. Gradually, the scientific findings and discoveries of the earlier periods were reduced to dogmas.

While in England, surgery and medicine passed from bone-setters and barbers to the royal colleges of surgeons and physicians, in the East it passed on from the schools of surgery and medicine to bone-setters, barbers and untrained physicians and surgeons.

This too came to a pass, and today, Āyurveda has returned to occupy a prime position in India. There are nearly 211 Āyurvedic colleges in India, affiliated to various Indian universities. Postgraduate courses are conducted in approximately 53 colleges. There are three to four central institutes dedicated to the science of Āyurveda. Gujarat Āyurveda University, Jamnagar-361008, India, is exclusively meant to promote Āyurveda at national and international levels.

Practice and Manufacture

Utilisation and role of the health services was very limited and disorganised. Hence, the Indian Drug and Cosmetic Act, 1940 was amended in 1964 to become applicable to the Āyurvedic system of medicine. The Pharmacological Laboratory of Indian Medicines in Ghaziabad, Uttar Pradesh was set up to standardise all Āyurvedic drugs. Standardisation of single and compound drugs is done by the Pharmacological Committee of Āyurveda, New Delhi. The National Medicinal Plants Board, New Delhi, looks into the scientific cultivation of plants. Plans are afoot to take up standardisation of basic principles and therapeutics in collaboration with the Central Council for Research in Āyurveda and Siddha, New Delhi.

Various scientific methodologies including chromatographic analysis are being adopted to evolve standards.

Manufacturing units have existed for years. For example, Indian Medicines Pharmaceutical Corporation Ltd, Uttaranchal, India in public sector and various leading commercial enterprises in private sector have been manufacturing pharmaceutical products for over three decades adhering to standardised good manufacturing practices.

2

THE OCEAN OF WISDOM

Nāsti āyurvedasya pāram
Samudra iva gambhīram

The knowledge of Āyurveda is compared to an ocean. Just as the ocean allows rivers and streams to flow into it and enriches itself, similarly, Āyurveda welcomes all other sources of medicine to enrich and enlarge its scope. Sophisticated and specialised scientific and technical methods can be easily and smoothly integrated into the basic principles of Āyurveda. Just as the ocean does not lose its individuality when it assimilates, similarly, the intrinsic quality of Āyurvedic aphorisms (*sūtras*) is not disturbed in any way when modern methods are added; on the contrary, the Āyurvedic system of medicine gets strengthened by this fusion of ideas.

Sūtra means a thread, which links different theories and their meanings and practices. Āyurveda is such a system that the moment one deciphers the principles for understanding their real essence and application, the system becomes operative far beyond the expectation of the concerned authority. It may be mentioned here that there is a strong view that the classical description may be better interpreted

and supported with available contemporary knowledge based on modern science and technology.

It is possible to explain modern concepts of anatomy, physiology, biochemistry, biophysics, ecology, economics, cosmology, behavioural science, allergy, hypersensitivity, immunity, and relationships without disturbing the basic structural and functional principles of Āyurveda.

Āyurveda is thus both classical and progressive in the sense that its eternal character helps to solve contemporary problems. Knowledge of the human body has always been of fundamental importance to mankind for its survival and attainment of physical, mental and spiritual development. Āyurveda shows man how to remove pain, sufferings and natural turbulences and to restore happiness, peace and ecological balance through various devices, measures and systems. A great deal of stress is laid on psychosomatic and spiritual treatment — a combination, which may be called a super-holistic approach.

In the Middle Ages, mechanised power increased tremendously. In fact, we can say that gunpowder killed sophisticated and enlightened thoughts. It was a victory of brute force over refined ideas. The present civilisation of physical science and technology was established through trade and commerce. The conquerors became rich nations and exploited their colonies. After the end of colonial era and with the advent of freedom, democracy and liberty, the entire movement took a new turn. Ancient sciences like Āyurveda are once again being revived and utilised.

AGE OF ĀYURVEDA

Āyurveda has been in existence since the dawn of mankind. The age of the universe is directly related to the age of Āyurveda. Cosmogony and cosmology indicate that the origin of the universe dates back to about a billion years. The most accepted theory is that of the 'big bang', which says that the universe started with an explosion. Continuous expansion of

the universe or 'big crunch', occurring at regular periods of time, indicates cycles of creation and destruction. These cycles are measured in terms of the life of Brahmā, the basic unit of which is a *yuga*. The following is the time classification according to the classical texts.

1st *yuga* (*sat yuga*) = 17,28,000 sidereal years
2nd *yuga* (*dwapara yuga*) = 12,96,000 sidereal years
3rd *yuga* (*treta yuga*) = 8,64,000 sidereal years
4th *yuga* (*kali yuga*) = 4,32,000 sidereal years
1 *mahayuga*, i.e. total four *yugas* = 43,20,000 sidereal years
1 *kalpa* =1000 *mahayuga* (= 43,200,00,000 sidereal years)
1 day of Brahmā =2 *kalpas*
1 Brahmā year=360 x 2 = 720 *kalpas*
Age of Brahmā =100 Brahmā years

Pralaya means the end of one yuga and the beginning of the next. At present, we are in middle of the *kali yuga*. In each yuga, there are 14 divisions or periods, each of which begins with *manuadi* or the birth of man. The first man of each *yuga* hears and remembers the knowledge and transmits it to his future generations. This process has led to the birth of various civilisations.

THE WAY TO KNOWLEDGE

Throughout the ages, as enumerated in classical treatises, it appears that the stress was on knowing the Ultimate Reality for liberation from birth and death. The quest for everlasting peace and happiness led to various theories and practices in each *yuga*. *Vedas, Brāhmanas, Āranyakas, Upaniṣads, Puraṇas* and other classics try to clarify and demystify many aspects of the complex interweaving of theories and practices. Ancient seers, savants and scientists, called *āptapuruṣa*, not only enriched the different branches of science but also society and civilisation as a whole. Availability of objective and instrumental methods explained specific aspects of Nature, man, mind and the basic five *mahābhūtas*.

The knowledge of the ages can be known through observation, inference, *yukti* (logical thinking) and teachings

of the great savants like the *sūtras* (aphorisms), *ślokas* (rhythms) and narrative descriptions. There are six ways of understanding the treatises. These are as follows:

- **Śikṣā:** Rules of pronunciation of the great writings.
- **Kalpa:** Rules of rituals and duties.
- **Nirukta:** Glossary of terms used in the classical treatises.
- **Chanda:** Study of metre, rhythm, tempo, stress and pitch of language.
- **Vyākaraṇa:** Rules of language.
- **Jyotiṣa:** The study of the movement and position of constellations and their effects on living as well as on inanimate beings. It also includes enlightenment as such.

All the six components mentioned here are essential to understand Āyurveda and its branches.

COMBATING DISEASES WITH ĀYURVEDA

The concepts of *mantra, tantra* and *yantra* are related to ancient science in general and to psycho-spiritualism in particular. *Mantra* signifies basic formulae and principles; *tantra* means to retain, wear, or make use of the body. In other words, any system or organisation working as an organic whole can be considered as a *tantra. Yantra* means instrument or device for operating the system in a certain way. These instruments may be living or non-living, designed as per the requirement of mantra. Accordingly, there are different *yantras* to achieve different aims in various branches of the ancient science.

The primary method of combating diseases in Āyurveda is the use of drugs, diet and practices that are *contrary* to the cause of the disease or the disease itself. In other words, drugs, food and behaviour should be used against either the causative factors or the disease itself or both.

The second method is to prescribe drugs, diet and behaviour that are *similar* to the cause of the disease or the disease itself. Aphorisms described as *upaśaya* have laid down another alternative — the medicine to be administered should be similar to causative factors but should work in an opposite

manner if it is to be effective. This is similar to the basic principle of Homeopathy conceived by Āyurveda prior to its application by Samuel Heinemann.

Samuel Heinemann, who lived from 1755 to 1853, had applied similar combinations. He had become increasingly disillusioned by the prevalent medical practice and devoted his attention towards research and writing, instead of routine medical practice. He found that small doses of cinchona or Peruvian bark (which homoeopaths call 'china'), from which quinine is derived for treating malaria, if taken by itself produces the symptoms of malaria. Further systematic research developed the system of medicine called Homeo-pathy with its principle of *similia similibus curentur* (let the likes be treated by likes). The requirement that diet and regimens need to be similar to the cause or disease, or both, still stands relevant in Homoeopathy for further investigation.

INDIGENOUS VIS-A-VIS MODERN MEDICINE

The importance of localised and alternative systems of medicine has now been realised. Indigenous systems of medicine are considered to be best suited to developing countries and nations. Homoeopathy, osteopathy, chiropathy, western herbalism and naturopathy, healing touch, aromatherapy, hydrotherapy, spiritual healing, Chinese medicine including acupuncture and acupressure, hydrotherapy, Āyurveda, etc. are the few systems of medicine which would be extremely useful in treating the millions who are suffering. The factors that work in favour of these healthcare systems are:

- Cultivation, trading and practices of indigenous herbs for use in these systems and other herbal systems not only develop the economy of a country, but also generate employment for people.
- Indigenous systems of medicine have cultural links with the masses. Faith and trust play a very significant role in treatment of a disease.

- These approaches are based on years of study and use and develop the immune system of individuals and society at large in a manner that appears to be beyond the scope of modern medicine.

- These are holistic systems of medicine. Āyurveda leads in this approach because of the rational, scientific, systematic, comprehensive and eternal basic principles. Keeping this in view, the World Health Organisation (WHO) has changed the definition of health while appreciating that traditional systems are holistic "because they view man in his totality within a wide ecological spectrum and emphasise the view that ill health or disease is brought about by an imbalance or disequilibria of man in his total ecological system and not only by the causative agent and pathogenic evolution" (WHO, 1978).

- Under these systems, diseases are diagnosed differently but conclusions are similar to that of modern western medicine. Drugs are classified differently but their utilities are also the same. Thus, nowadays, standardisation of drugs is being done as per the procedures adopted by allopathic pharmacopical authorities of the world.

- Āyurveda is not primitive in nature. This has been proved by technology in various fields, including environment, immunology, genetics, medical botany, psychology, etc. and the depth of knowledge contained in the Āyurvedic system of medicine has been well established.

- The use of single and multiple-drugs treatment, prescribed by Āyurveda, is today being appreciated for certain diseases by modern medicine. For instance, chemotherapy employed in treatment of cancer is both non-synergistic (single-drug) and synergistic (multiple-drug) in nature as per the demand of the disease. Similarly, Āyurveda preparations contain many ingredients in various forms such as powders (cūrṇa), self-fermentation and self-generating alcohol called āsava and ariṣṭa, etc.

- Under Āyurveda and other traditional systems, food, drug and behaviour have been categorised according to their

tastes, properties, potentialities and effectiveness. Western scientists are investigating these concepts now.
- Āyurveda uses energy management to cure acute cases. Skin diseases, burns and other traumatic conditions can be treated with Āyurvedic preparations.
- Modern cosmetic preparations contain Āyurvedic drugs. Āyurvedic digestives and appetisers are very much part of the modern kitchen.

Apart from the above facts, systematic research is being conducted to evaluate therapeutic efficacy as well as toxicity of Āyurvedic preparations. In today's age, drug tolerance level has increased considerably because of toxicity. This should be decreased while following the Āyurvedic line of treatment which calls for detoxifying the body and mind in the first instance, before prescribing simple, cost-effective and efficacious drugs. Eco-friendly treatment will increase physical and mental stamina.

The world is moving towards community or social medicine. The budget for health and treatment of diseases is more than 12 per cent of gross natural product. Diseases caused due to poverty are being given priority. Maintenance of the ecological balance is being stressed among the masses. Organic manure is now extensively used in most countries. Biotechnology is receiving higher attention. Considering all this, we can safely say that the world is turning over a new leaf and Āyurveda is one such medical system that can take up the challenge.

3

THE HOLISTIC WAY

During the nineteenth century, the importance given to individual experience, which could not be measured, diminished further as everything was reduced to scientific solutions. Intuitive wisdom of healers was dismissed as anecdote. The toxic nature of allopathic remedies, which gave rise to various side effects, finally led to the development of less noxious, alternative approaches such as Homoeopathy. Complementary approaches to health enjoyed a revival but they frequently were met with open hostility and derision from the allopathic community.

Medicine during this time was an eclectic pursuit in which a number of competing ideas and approaches thrived. Doctors were able to draw on elements from different traditions in attempting to cure people. Different beliefs put forward different views of the same reality. The observer's preconceived ideas influenced the objective observation of reality.

While all this was going on, J.C. Smuts, the South African statesman, coined the term 'holism' in 1926. He was of the view that the various parts of an organism should be looked into as a whole and not separately when looking for the cause

of a disease or ill health. Later on, humanistic and psycho-social approaches in healthcare were stressed. Subsequently, 'holism' was defined as an integrated approach to a sick person, who was thought to be in a state of imbalance with his environment in respect to his physiological, mental and moral relationships. It was, however, criticised on the ground that it was an endeavour to abandon reason and science in favour of mysticism and occultism.

There was also a re-emergence of the vitalisation theory of health before holism came into being. It was stimulated by the teachings of Jesus Christ. The early Christians belived in the beneficial effects of ecclesiastical intervention in cases of possession, concussion and trance states. This was later suspected to be paganism bordering on witchcraft and satanic in nature. However, this cannot be dismissed so easily and has to be evaluated keeping in view the fact that Jesus Christ practised yogic *siddhi* for 40 years.

Today, telemedicine is stepping in and computers and the Internet help in diagnosis of diseases. The doctor-patient relationship, however, still retains its importance. Positive attitude in dealing with patients and their relatives on the part of the doctor increases the effectiveness of health promotion programmes and prevention of diseases.

Herbal system of medicine is not replacing Allopathy. But it is becoming popular on its own merits.

THE UNION BETWEEN SCIENCE AND SPIRITUALISM

Life is a unique experience of self-realisation, and the self has to make an effort for reaching the goal of liberation. For this, health is needed. Āyurvedic science is concerned with the union of and balance between happiness and pain.

Observations and diagnoses are based upon valid proofs or testimonies, direct observations, inferences, directive principles of authorities, rationalism, and revelation. The knowledge required to understand the science and philosophy of Āyurveda is stored in aphorismic forms in various texts.

These are classified into two categories — *śruti* (heard discourse) and *smṛti* (remembered discourse).

Āyurvedic concepts, principles, theories, techniques and practices have been derived from the understanding of wholesomeness (state of health) and unwholesomeness (state of sickness/illness). It is also about applying these standardised techniques to achieve the well-being of the body, mind and soul. Āyurveda explains the factors that are responsible for the self-healing power of an individual.

Āyurveda recognises bio-energy as the radiation of sun. Āyurvedic believes that bio-energy is working on each living cell, tissue and system. Living beings in any form are said to be able to exist only if they maintain a harmonious relationship with other living and non-living beings. These ideas in turn lead to standardised generalities (*sāmānya*) or specifications (*viśeṣa*). Actions and reactions of these generalities and specifications lead to wholesome or unwholesome situations.

The self is just like a drop of water going back to the ocean of its own original existence. It is born again as a drop from rain originating from the ocean in the form of a cloud. Ego generates differences, hatred, lust, greed, attachments, etc. These are causes of imbalance. The moment a person realises that he or she is just one drop in the mighty ocean and all beings are equal, all positive forces operate to bring oneness with the Ultimate Reality. This state of oneness nullifies all types of illness, sorrow, pain as well as joy, happiness and attachment. This ideal state of neutrality is the real basis of a holistic approach.

At a pragmatic level, the term 'holistics' can be applied to the state when all the four components of treatment in Āyurveda — drug, physician, patient, nurse — work well.

A UNIVERSAL SYSTEM

Āyurveda is an open system. Eclecticism is ingrained in its very soul. Āyurveda feels that there are many *tantras* to attain the desired goal. It rests its faith in the common man whose

beliefs may give the idea or the right path leading to the truth because of his experience as a son of the land. It believes that a wise person always welcomes noble, good and useful ideas. This is a holistic approach to learning and achieving targets.

Āyurveda is a holistic medical system because its basic tenets touch each and every system conceived by scientists, research scholars and medical authorities. There are aphorisms that, besides allopathy, explain Homeopathy, osteopathy, chiropractic herbalism, healing by touch, aromatherapy, naturopathy, yogic therapy, altruism, and spiritual or faith healing. It thus lays down fundamentals of medicine in its true and verifiable form.

Āyurveda lays more emphasis on the human body than on pathogenous micro-organisms. Its main approach is to build up the immune system, but it is not against the killing or neutralising of the micro-organisms responsible for ill health, as is commonly believed. There are detailed processes highlighted for determining drug resistance of micro-organisms and side reactions along with their treatment. Āyurveda advocates surgery when other branches of general and internal medicine fail to cure patients. It does not claim to be exclusively correct but instead acknowledges the validity of any idea, system or methodology that establishes a dynamic equilibrium between the inner micro-cosmic universe and outer macro-cosmic universe.

Āyurveda is not an alternative medicine but the 'mother of medicine'. It incorporates biomedicine and non-biomedicine; it is a bridge between two realms or apparently opposing concepts, i.e. non-materialism and materialism. For example, Āyurveda includes both *kāya cikitsā* (internal medicine), which is materialistic in nature, and *bhūta vidyā* (psychiatry or psychotherapy) that is mostly non-materialistic in nature.

Āyurveda not only treats the disease but also the patient. It views the patient as an entity whose various parts are to be united through stages of enlightenment. It is a highly

psycho-technological system that requires the active participation of the patient and the physician. Āyurveda begins with prevention and promotion of health and ends at curing psychosomatic diseases. Clinical observations and pharmacological findings establish scientific authenticity of the classical treatises. Not inferior to any other bio-medical system, it believes in gaining from all modern advances to maximise its potentiality.

DOES ĀYURVEDA REALLY WORK?

Why is it that indigenous systems of medicine are gaining popularity when allopathic medicine and surgery are more powerful and advanced than ever before? While modern medicine is in a position to look deep into the body with systems like Magnetic Resonance Imaging (MRI) and technologies like genetic engineering, etc. Disease prevention, chronic illnesses and psychological weaknesses are areas where allopathy is far less effective as compared to Āyurveda.

Āyurvedic efficacy can be measured both subjectively and objectively. Faith and trust influence a person's health positively. Contrary to this, a faulty bent of mind influences negatively. Āyurveda uses a defensive mechanism. *Vāyu* innervates the bone marrow, thymus, spleen and mucosal surfaces where immune cells develop, mature and encounter foreign proteins. What is even more important is that Āyurvedic conceptions and basic principles do not limit the use of any substance or drug and surgical intervention. Side reactions arising from allopathic treatment are in fact cured by Āyurvedya.

According to Āyurvedic principles, the body is composed of channels and there is nothing other than these channels in the body. Āyurveda has also explained the body from the viewpoint of biological cells called *paramāṇu*. These may be considered as living micro-units. If these are destroyed then life does not exist in the body.

There are five cavities as enumerated. These are:

(a) *Annamaya koṣa:* The portion of the body where food is stored.

(b) *Prāṇamaya koṣa:* The portion of the body where life-giving energy called *prāṇa* is stored.

(c) *Manomaya koṣa:* That portion of the self where the mind of the individual resides.

(d) *Vijñānamaya koṣa:* The part of the self-containing scientific knowledge.

(e) *Ānandamaya koṣa:* The part of the self that contains extreme and noble forms of happiness called *ānanda*.

4

BASIC CONCEPTS OF ĀYURVEDA

People look at Āyurveda in various ways: cheap medical relief; folk medicine; empirical medicine; traditional faith therapy; treatment for incurable diseases; traditional herbal medicine, and so on.

Despite the fact that most modern research scientists and votaries of Āyurveda find it a veritable goldmine for future work and consider it a complete science, there are others who are sceptic about the wonders it is capable of doing. Taking into account the advances made by science, it is perhaps natural for the doubts to arise and ask whether the concepts of Āyurveda are based on a rational and scientific outlook, whether the surgical techniques are really effective and safe, and whether the system has to be supplemented by some amount of modern science. These doubts are aggravated by the fact that the technical terms have not been standardised.

In order to understand Āyurveda, it may be very useful to forget the concept of matter as detailed by Aristotle, Hippocrates, Galen and other philosophers of Greece. The definitions of Āyurveda — *āyu* (life span), *dravya* (substances), *śarīra* (katabolic body), *deha* (anabolic body) may clear some of the doubts. The understanding of *pañcabhūtas, tridoṣās, rasa,*

guṇa, virya, vipāka and *prabhāva* also help in understanding the subject.

Let us examine space, which is termed as *ākāśa*. An intrinsic quality of the all-pervasive space is sound. The infinite calm and silence that seems to surround the earth is deceptive. The world is pierced by myriads of electromagnetic waves, which fill it with oscillations not perceptible to unaided ears. The sun in our galaxy is at a distance from the earth and maintains life on earth. Human beings or rather living beings maintain a similar dynamic equilibrium inside their own bodies while facing various forces outside. The process of generating heat inside the body is a miniature of the heat in the universe. Electromagnetic storms travel thousands of millions of kilometres to reach us. Similarly, the same electromagnetic waves move in the body through *prāṇavaha srota* for vitality or life as such. Air, heat, water and earth outside explain the same entities exist in the body.

BASIC PRINCIPLES OF ĀYURVEDA

The basic principles of Āyurveda are based on the tenets of visionary authorities like Gautama. Each authority had its own schools of thought which are:

Visionary Authority	Visionary School
Gautama	Nyāya darśana
Kanada	Vaiśesika darśana
Kapila	Sānkhya darśana
Patanjali	Yoga darśana
Jaimini	Pūrva mimāṁsā
Vedic authorities	Uttara mimāṁsā

There is a very strong view that holds that Āyurvedic visionary thoughts are quite independent and were not borrowed from any other school of visionary thought. There are two viewpoints in this regard. Firstly, the Creator who created Himself, Swayambhu, also created Āyurveda. So, the question of borrowing any system or combination of systems does not arise. This view of creation of Āyurveda is detailed in the *Suśruta Saṁhitā*.

The second view is the more popular one. Ṛṣi Bharadwāja, according to this, acquired the knowledge from Indra, the king of heaven, after spiritualism, yogic expertise and visionary thoughts failed to maintain health and cure people of illnesses. The principles and basic fundamentals learnt from Indra had their own approaches and scientific explanations. Modern students of Āyurveda take into consideration both the traditional *darśanas*, Āyurvedic principles and contemporary scientific and technological concepts, so that Āyurveda finds wider acceptance and becomes improved and strengthened to solve contemporary problems related to life and health.

Human beings have five sense organs, so there are five symbolic representations. Further, to simplify these five pro-elements, they were categorised into three basic evolved elements. It was felt that both the ears and the skin sense sound or vibrations of sound. Thus, ears and skin were needed simultaneously and in combination came to be called *vāta*. *Pitta* or *agni* contains the properties of touch and sight. *Kapha* represents *rasa* or taste and *gandha* stands for smell. *Kapha* also contains secondary characteristics of sound, touch and sight. Any earthly being must be composed of these three basic entities. This is the *tridoṣā* (*tri* = three + *doṣā* = faults) theory.

The *tridoṣā* are so called because they form a net that becomes bondage for the free soul called *ātma*. From the spiritual point of view, these are blemishes, defects, sins, faults and perversions because these three representatives of the five basic evolved entities carry out all the actions, reactions, processes, integration and disintegration related to the material world.

DARŚANA

'*Darśana*' is a term considered to be equivalent to 'philosophy' or 'metaphysical discourse'. The word *darśana* is derived from the root '*Dṛs*' that is to 'see'. The dictionary meanings of '*Dṛs*' are: to search, to inspect, to examine, to decide and then see

by divine intuition. *Darśana,* which is a noun form of the root *dṛs,* appears to refer to the act of looking at, understanding, perceiving, vision, examination, etc. It is considered the actual experience of the observer. He lives with it and becomes a part of it. The philosophy of various schools, general reasoning, abstract speculations, subtle talks, theoretical exercises and arguments, decisions or conclusions constitute essential part of *darśana.* However, one has to follow a rigid and objective methodology of evidences, called *pramāṇa,* with a view to elucidate truth or to arrive at proper knowledge supported by actual realisation without fallacious ideas and fanciful flights in air.

Nyāya and Vaiśesika *darśanas* are concerned with findings related to correct and true knowledge based on all four aspects of *pramāṇa:* (a) *pratyakṣamāṇa* or direct observation, (b) *anumāna* or deduction and induction, (c) *upamāna* or analogy and (d) *śabda* or authoritative statement. Sāṅkhya *darśana* on the other hand is based on only *pratyakṣamāṇa* and *anumāna.*

The methodology usually followed in Āyurveda for elucidating the true nature of the phenomenon of life is that of Sāṅkhya *darśana. Yukti* (reasoning) is a rational approach to determine the truth and to eliminate false and incorrect motions. It is obvious that all phenomena exist due to a multiplicity of causes. The stress was to analyse each factor and this could thus be considered a statistical investigation in some respects.

There is also a cross-examination of the result obtained through elimination by an unwarranted stretch of principles (*ativyāpti*), non-comprehensiveness (*awāpti*), and improbability (*asambhava*).

Āyurvedic *darśana* is not an 'interesting intellectual pastime'. It has both theoretical and practical value. It is a science that aims at the explanation of all phenomena under cause and effects. It further gives the ultimate cause of all universal phenomena, besides explaining physics, chemistry, biology, metaphysics and ethics. It gives integrated and holistic views, approaches and thoughts.

Some Aspects of *Darśana*

Integration and disintegration are natural phenomena that are both causes and effects. These are termed as *prakṛti* and *vikṛti*. It is natural that when the desired effect is reached, a limit is enforced. Otherwise, there would be no end to this continuous process of integration and disintegration.

According to Āyurveda, the universe is composed of a conscious being called *puruṣa* (*pur* = abode, i.e. body, *isa* = Ultimate Reality). The *puruṣa* is conceived as a part of the Ultimate Reality in Āyurveda so that the link of the individual with Ultimate Reality is not forgotten.

From the Ultimate Reality, which is considered to be unmanifested (*avyakta*), evolves the intellect (*mahāna*). From the intellect, ego (*ahaṁkāra*) evolves. This is the main cause of bondage and involvement of an individual with worldly affairs and forgetting the original, faultless, pure and sublime state. Ego has three different aspects, viz. *sāttvika, rājasika* and *tāmasika. Sattva* indicates the finest and purest state of ego. *Rajas* reinforces dynamism and signifies action. *Tamas* is the lowest, unrefined potential energy of ego.

Sāttvika and *rājasika* combine together to produce eleven organs, i.e. the five sense organs, the five motor organs and the mind, which is linked with sensory as well as motor organs. The *rājasika* and *tamasika* aspects of mind combine to produce five *tanmāntras* called *śabda, śparsa, rūpa, rasa* and *gandha*. From these five *tanmāntras*, five *mahābhūtas* originate, from which in turn, the entire universe is created.

TIME (*KĀLA*)

Āyurveda recognises *kāla* (time) as one of the nine fundamental substances. Its existence is eternal. Actions and attributes reside concurrently, inherently and simultaneously. Every type of existence is perceived as well as conceived in the substratum of time. The present time is just a passing phase. Vedic seers have advocated elaborate methods for this measurement. One method is:

1 *asu* (or *prana*) = 4 seconds
6 *asus* = 1 *pala* or 24 seconds
60 *palas* =1 *ghati* (24 minutes)
60 *ghati* =1 day (24 hrs)
30 days =1 month
12 months =1 year
4,320,000 years =1 *yugas*
72 *yugas* =1 *manu*
14 *manus* =1 *kalpa*
2 *kalpas* =A day and night of Brahmā
30 day-nights of Brahmā = 1 month of Brahmā
12 months of Brahmā = 1 year of Brahmā
100 years of Brahmā = life of Brahmā (or 1 *mahākalpa*)

The *Gītā* has stated that all visible beings emerge from the unmanifested reality, named Brahmā during the day. All these merge with the same unmanifested reality at night. The days and nights referred are Brahmā's days and nights (shown above). The concept of ancient astronomy is very comprehensive and does not belong to the scope of this book. However, it is quite obvious that time was probably measured from the position of the sun. There are two *ayanas*. The first *ayana* is called *uttarayana* (apparent northerly course of sun at the winter solstice from the Tropic of Capricorn). The second *ayana* is *dakśinayana* (apparent southernly course of sun at summer solstice from the Tropic of Cancer). There are 12 zodiac signs and the sun's apparent movement brings six seasons. These are related to the *ayanas*. The six seasons and ayanas are given below.

Ayanas	Name of Seasons	Approx. Period	Months of Saka Era
Uttarayana	*Śiśira* (late winter)	Jan. 21 to Mar. 20	Magha–Phalguna
Uttarayana	*Vasanta* (spring)	Mar. 21 to May 20	Chaitra–Vaiśaka
Uttarayana	*Grśma* (summer)	May. 21 to Jul. 20	Jeṣṭha–Ashadha
Dakśinayana	*Varśā* (rainy)	Jul. 21 to Sept. 20	Srāvasana–Bhadrapada
Dakśinayana	*Sharad* (autumn)	Sept. 22 to Nov. 20	Aświna–Kārtika
Dakśinayana	*Hemanta* (winter)	Nov. 21 to Jan. 20	Margaśirsha–Pauṣa

The effects of *uttarayana* are dehydration, drying of strength and vigour of the individuals. On the contrary,

dakśinayana is health giving and human beings acquire strength. However, it is a gradual process and climatic changes do not bring about sudden wholesome and unwholesome effects.

The changing seasons affect the *doṣās* as well. From January 21 to March 21, *kapha* is accumulated, i.e. building material is available to individuals. During the summer season, *kapha* is suppressed from May 22 to June 21 and *vāta* is accumulated. From July 22 to November 21, *pitta* is accumulated and is suppressed from November 22 to January 21. From July 22 to September 21, enema and hot oily treatment is recommended due to provocation of *vāta*. From September 22 to November 21, purgative and a cold soft treatment is recommended to combat *pitta* provocation. From March 22 to May 21, forced vomiting and hot dry treatment is recommended because of *kapha* provocation. It has been observed that the *kapha doṣā* is provocated in the morning and during childhood. *Vāta doṣā* is provocated in the evening and old age. *Pitta doṣā* is provocated at noon and in middle age.

Adverse changes in seasons cause diseases. These ecological changes concern the society as well as the individual. The society has to adapt just like individuals. Adverse adjustments and responses cause infection as well as physical, chemical and emotional stresses. Āyurveda has advocated avoidance and neutralisation of the causes that are responsible for imbalances between living beings, society and the universe.

DOṢĀS

In order to understand the *doṣās*, which are primary elements, the concept of the five basic elements called *pañcamahābhūtas* is to be made clear. In order to know the world, the individual has five sense organs. For each sense organ there is one conceived entity, called *bhūta*. The functional projections of the five primordial entities have been grouped into three — *vāta, pitta* and *kapha doṣās*.

Vāta represents space and air functionally, viz. *ākāśa tattva* and *vāyu tattva.* It is of five types, each type representing various functions of *vāta*, according to which their names have been given.

(a) *Prāṇa:* It is located in the heart. Apart from breathing, the swallowing of food is done by this *prāṇa vāyu.* Vitiated *prāṇa vāyu* causes hiccups, bronchitis, asthma, cold, influenza and hoarseness of voice.

(b) *Udāna:* It is located in the throat and is responsible for speech and voice. Vitiated *udāna vāyu* causes various diseases of eye, ears, nose and throat.

(c) *Samāna:* It is located in the stomach and small intestine. It is responsible for the digestive process and action of enzymes. It equalises the process of the supply of requisite foods to the tissues. The regular functions are affected when it is vitiated.

(d) *Apāna:* It is located in the colon and the organs of the pelvis. It removes stool, urine, semen and menstrual blood. When it is vitiated, diseases of sexual organs and the urinary system with pain in the anus may be caused.

(e) *Vyāna:* It is located in the heart. It is responsible for the circulation of blood and other fluids through channels. It may cause impairment of circulation and fever, etc. when vitiated.

Pitta Doṣa

Pitta represents fire or *agni tattva.* There are five types of *pitta*:

(a) *Pācaka:* It is located in stomach and small intestine. It performs the function of digestive system. Vitiated *pācaka pitta* may cause indigestion.

(b) *Rañjaka:* It is located in liver, spleen, stomach, bone marrow. It is meant to form blood. Vitiated *rañjaka vāta* causes anaemia, jaundice, etc.

(c) *Sādhaka:* It is located in the heart and is responsible for memory and other mental functions. Psychic disturbances may be caused when *sādhaka pitta* is vitiated.

(d) *Ālocaka:* It is located in the eyes and is responsible for vision and impairment of vision when vitiated.

(e) *Bhrājaka:* It is located in the skin and is responsible for colour and glaze of the skin. It may cause skin diseases when vitiated.

When it is stated that *pitta* has been vitiated, then more often than not, it is *pācaka, rañjaka* or *alocaka pitta* that is affected as compared to other types of *pitta.*

Kapha Doṣa

Kapha represents water and earth, in their functional forms, viz. *jala tattva* and *pṛthvī tattva.* It is also of five types:

(a) *Kledaka:* It is located in the stomach and provides *kledaka* (a mucous substance), which is needed for digestion. Vitiated *kledaka* causes indigestion.

(b) *Avalambaka:* It resides in the heart and protects it. When vitiated, it may cause cardiac diseases.

(c) *Bodhaka:* It is located in the tongue for identification of taste. It may communicate wrong taste if vitiated.

(d) *Tarpaka:* It is located in the heart for nourishment of sense organs. Vitiated *tarpaka* causes loss of memory and impairment.

(e) *Śleṣaka:* It is located at the joints for lubrication. Vitiated *śleṣaka* causes pain in joints and malfunctions of joints in movement, etc.

Aggravation of Doṣās

Vāta: Taking dry, cold and astringent food aggravates *vāta.* Suppression of natural urges for excretion of unwanted matter from body, taking food without feeling hungry, doing excessive activity such as not sleeping at night, speaking continuously with a loud voice, doing physical exercise that exceeds one's strength, etc. also aggravate it. The rainy season is not good for nervous diseases.

Pitta: It gets aggravated by excessive intake of pungent, sour, salty food and alcoholic drinks with spicy and irritant food items. Anger, excessive exposure to sun, hot air, fire,

fatigue fear, intake of dry vegetables, indigestion, irregular eating habits are some causes of aggravation of *pitta*. The autumn season aggravates *pitta*.

Kapha: Taking heavy, oily, sweet foods aggravates it. Sleeping during the day, eating cold fish and mild and unctuous items, having sugar in large quantity, cakes, toffees and confectionary articles may cause aggravation of *kapha*. *Kapha* is aggravated during the spring season.

Signs and Symptoms of Aggravated *Doṣās*

Vāta: Aggravated *vāta* is inferred by roughness, dryness, contraction, pain of various types such as colic pain. Colour of the skin may change. Abnormal movement of limbs, fracture, numbness, feeling of cold, dryness, loss of weight and tissues are other signs.

Pitta: Aggravated *pitta* may cause excessive sweating, fatigue, loss of body fluid, burning sensation, change of colour of skin, bad breath, loose skin, fainting spells, giddiness, incoherent speech and mental abnormalities.

Kapha: Aggravated *kapha* causes heaviness, coldness and unctuousness. The individual feels as if he is covered with wet cloth or a layer of some undesirable material. There is swelling, excessive exudation and delay in responding to stimulus.

Treatment of Ailments caused by Aggravated *Doṣās*

Vāta: Alleviation of *vāta doṣā* is to remove main causes of vitiation or aggravation. So, drinks, diet, regimens and medicine should be unctuous, hot, stable, strengthening and promoting stamina; oils of sweet and sour articles are to be used. Massage, exposure to sun, enema, inhalation therapy, proper rest and sleep, application of hot ointments or *lepas*, enema with indicated oils or decoctions remove vitiated and aggravated *vāta doṣā*.

Pitta: Alleviation of *pitta* lies in having a regimen of drinks, diet, and drugs that are bitter, sweet and astringent. Cold wind, shade, moon rays at night, soothing music, basement residence, fountains, fragrance, animal fat especially of cow's

milk, fanning with sprinkling of water, purgation, blood letting and avoiding anger and fire are recommended. *Pitta* can be corrected by purgation and by soothing application of ointment on the body.

Kapha: Alleviation of *kapha* rests on prescribing a regimen of drinks, diet and drugs that are rough, dried, alkaline, astringent, bitter and pungent. Exercise, emesis, sexual indulgence, walking, fighting, remaining awake, pressing body with hands and feet, systematic fasting, inhalation therapy, sweating, steam-bath, applying hot ointment, etc. are recommended.

In case, there is a combination of *doṣās*, a mixed therapy may be used.

DEFINITION OF HAPPINESS AND UNHAPPINESS

Āyurveda has given a simple but comprehensive definition of *sukha* (happiness) and *dukha* (unhappiness). When the basic proto-elements and supportive tissues, i.e. plasma, blood, muscle, fat, bone, bone marrow, sperm/ovum are not in natural proportion then deterioration, defects and perversion are caused.

The cause of *arogya* (being devoid of disease) is named as *sukha*, i.e. happiness that includes relief, well-being, tranquillity, equilibrium and a balanced relationship of the individual with ecology as also socio-economic and political set-up.

Social disharmony is caused by imbalances of supportive elements, for example, unequal distribution of wealth, exploitation of political power, selfish motives of authorities given to judicial power, and hatred generated by emotional upheaval. These causes disturb equality, individuality and liberty. Dynamic social equilibrium brings a natural state of happiness.

The four basic desires are: (a) *dharma*, (b) *artha*, (c) *kāma*, and (d) *mokśa*. Happiness in Āyurveda is a balance in these four basic desires of an individual as well as society.

5

CONCEPT OF HEALTH

The philosophy of health is very simple according to Āyurveda. There should be an equilibrium between *doṣās*, which are three in number, *agnis*, which are 13 in number, *dhātus*, which are seven in number, *malas* (excretions) and *kriya* (physiological functions). Secondly, the soul, sensory and motor organs and mind should be content and cheerful. All of these put together constitute health.

The same concept applies to social health. Processes such as trade, commerce, industries and disposal of waste products should be balanced. The various sections, castes, communities, creeds and weaker sections of the population should be happy. Health, in Āyurveda means, 'to be happy in respect of feelings, emotions, thoughts as well as experiencing a feeling of oneness'.

The gurus of Āyurveda have propounded various reasons and causes of diseases. The sage named Pārīkṣi expressed the view that the individual is an outcome of *ātma* (soul). So, according to him, the birth of an individual and of disease are both due to the soul. Feelings of good and evil are experienced because there is a soul in the body. Without the soul, there is no disease, pain or happiness.

Śaralomā thought that disease is due to energetic and crude *tamas*. Śaunaka was of the view that all diseases that occur in the offspring are due to the genetic structure handed down by parents. Bhadrakāpya expressed that actions are responsible for birth and diseases. Bharadwāja put forward the theory of spontaneity.

Kānkāyana was of the view that Prajāpati, the son of Brahmā, is the cause of birth and disease including health and illness. Bhikṣu Ātreya was of the view that Prajāpati loved his creations so he could not be the cause of disease and instead, time or *kāla* is the cause of birth and disease. Ṛṣi Punarvasu concluded the debate and propounded that those elements in their best form responsible for the birth of individuals become causes of death in their bad form.

SUB-PILLARS OF HEALTH

Āhāra (food), *nidrā* (sleep) and *brahmacharya* (celibacy) are very significant and essential aspects for supporting life. Āyurveda considers these three the sub-pillars for subsistence and maintenance of health, improvement of our body's defence mechanism, and prevention and cure of diseases.

Food (*Āhāra*)

Food is obtained from vegetable and animal kingdoms. Some are useful and others are not. There are six tastes — *madhura* (sweet), *amla* (sour), *lāvaṇa* (salty), *kaṭu* (pungent), *tikta* (bitter) and *kāsāya* (astringent).

Food can be taken in four forms:

 (a) drinkable
 (b) eatable
 (c) chewable
 (d) lickable

In Āyurveda, all foods can be classified according to the proportion of the following properties:

1. *Guru* (heavy)
2. *Laghu* (light)
3. *Manda* (dull)
4. *Tīkṣna* (sharp)
5. *Śīta* (cold)
6. *Uṣna* (warm)
7. *Snigdha* (unctuous)
8. *Rukṣa* (ununctuous and devoid of oil)
9. *Ślakṣna* (smooth)
10. *Khara* (rough)
11. *Sandra* (dense)
12. *Dravya* (liquid)
13. *Mṛdu* (soft)
14. *Kaṭhina* (hard)
15. *Sthīra* (stable)
16. *Sara* (mobile)
17. *Sukṣma* (subtle)
18. *Sthula* (gross)
19. *Viṣada* (non-slippery)
20. *Picchala* (slippery)

Food has also been classified into different categories as given below. Under each category, there are various food items:

1. *Śukadhānya* (grains)
2. *Śamidhānya* (pods)
3. *Māṁsa varga* (animal flesh)
4. *Śāka varga* (green leafy vegetables)
5. *Phala varga* (fruits)
6. *Harita varga* (green group)
7. *Madya varga* (wines)
8. *Jala varga* (water and non-alcoholic drinks)
9. *Dugdha varga* (milk)
10. *Ikśu varga* (sugar)
11. *Kṛtānna varga* (processed category)
12. *Āhārayoga varga* (any other edible item)

Food plays a vital role in the development and growth of the *rāśi puruṣa* or the congregated person. So much so, that the *rāśi puruṣa* is said to be an outcome of food or nutrition. Diseases are caused as a result of impaired nutrition and malnutrition.

Lord Punarvasu Ātreya explained that when man was created, he was in excellent condition but over a period of time he gave birth to disease. A story has it that King Vāmaka, in ancient times, asked Punarvasu how to increase the good qualities for fighting disease, and what were the bad qualities or ingredients that led to birth and disease of living beings. Lord Punarvasu replied, "Wholesome food is the cause of increase in good qualities and unwholesome food is the cause of increase of disease."

It is clear that the birth of tissues and death are an ongoing process. New cells replace the dead ones continuously. This process of building, utilising vital energy and death of old tissues as well as rebirth of new tissue elements is possible due to food. This vital process occurs due to many factors, which are grouped under the term 'inner fire' or *agni*.

Concept of Nutrition in Āyurveda

Āyurvedic texts give comprehensive descriptions of the nature of food, nutrition and its application relating them to socio-economic conditions, geographic environment, climatic variations, sex, age, individual constitution, practical utility and equitable distribution of nutrients in various parts of the body.

Science of nutrition, as described in Āyurveda, is the study of all the processes of growth, maintenance and repair of *doṣās*, *dhātus* and *malas*, all of which depend on the intake of food against the background of the relationship an individual has with the universe. The digestive system provides the basic material, which is converted into different body elements (*rasa, rakta, māsa, meda, asthi, majjā* and *śukra*) with desirable qualities and quantities through metabolic processes. Food also provides energy necessary for growth, life and reproduction.

Āyurveda talks of six *rasas* or tastes. There are 63 combinations and permutations of these tastes and these play a vital role in maintaining a balanced diet. A balanced diet must have all the *rasas* in it. Excess or deficiency of any *rasa* causes imbalance and can affect one's health. Each *rasa* has its own distinctive reaction in the body because of the different combinations of the five *bhūtas* or elements—*pṛthvī, jala, agni, ākāśa, vāyu*—in the *dravya* or substance.

Digestion and assimilation is followed by *vipāka* or special digestion, which is powerful in nature. There are three types of *vipākas*, i.e. *madhura, amla, kāṭu*.

Manual of Nutrition

Different types of individuals require different types of diets. Āyurveda prescribes diets according to season, age, individual requirements and so on. The factors which subscribe to the *Manual of Nutrition* are: (a) *āhāra prakṛti* (quality of food), (b) *karna* (food technology), (c) *samyoga* (combination), (d) *rāśi* (quantity of food), (e) *deśa* (habitat), (f) *kāla* (time and climatic conditions), (g) *upayoga* (rules of use) and *upayuktā* (user), and (h) *agni* (efficiency of digestion, absorption and utilisation).

These factors, because of variation in effects due to different measurements, time and mode of preparation, habitat of the drug or herb, body constitution and humour of the patient, show themselves either as healthy or unhealthy conditions of diet.

Food or nutrition has been studied in Āyurveda in line with modern nutritional medicine. Out of the eight factors mentioned above, the four main factors that influence nutrition are (a) *prakṛti*, (b) *rāśi*, (c) *agni*, and (d) *upayukta* and *upayoga*. These have been enumerated by Davies and Stewart (1987) and detailed in Āyurveda along with the other factors: *karna, samyoga, deśa* and *kāla*.

The chemical assessment of one's nutritional status is considered a very important tool to diagnose certain diseases. In Āyurveda the biological action of food and their *rasa* play

a significant role. For example, all varieties of rice may, on one hand, be treated as one group on the basis of carbohydrate content. On the other, there are differences between different varieties of rice. Freshly harvested rice is heavier than old rice. Different types of rice have different nutritive values and pharmacological actions. Rice types such as *śāli* and *ṣaṣṭika* alleviate bodily faults whereas *vrīhi* aggravates them.

Starch content of different fruits and pulses produces different pharmacological effects. In addition to carbohydrates, fatty acids and water, there are amino acids, and at least 13 vitamins and 19 minerals that are indispensable to human life. Āyurveda stresses on the use of food that contains all types of *rasas* or tastes. Furthermore, it has been emphasised that different types of food are nutritional for different parts of the body. For example, Āyurveda prescribes food for the eyes to see properly, food to enhance the power of smell, food to hear properly, food to enhance the feeling of touch.

Foods meant for different sense organs lead to different therapies. For example, therapy by hearing different sounds and musical notes is called music therapy. Skin takes in food through touch therapy. Food for the nose is given through aromatherapy. Food for the mind plays a vital role in psychiatric treatment. Spiritualism and other occults as well as mystic therapies also have a place in Āyurveda. Scientists are evaluating these therapies in the context of biochemical and hormonal changes. Research in the field of psychoneuro immunology has demonstrated positive results. Even, placebo has been accepted positively. It is considered to be safe, cheap, without side effects and the patient has greater control over his body.

The principle of adaptation (*sātmya*) as described by Āyurveda may solve our problem. Metabolism and endocrinology have to be studied from new points of view: the body is the outcome of nutrition. Impaired digestive system and malnutrition are the causes of disease. *Caraka Saṁhitā* says, "The body is the product of food and food is the cause

of happiness (health) or unhappiness (disease)." Nutrition may also cause disease, if it is not accepted or adapted to by the body. Diets have to be analysed and evaluated. Formation of tissues, production of energy and rejection of unwanted elements called *malas* are some things that are to be considered. Secretion of hormones and even immunity are affected by the kind of food we take. Psychological factors of taste, smell, aroma and the characteristics of food, whether drinkable, lickable or masticable, play a vital role. Hence, the meal-in-a-pill cannot be considered a regular healthy food.

Synthetic foods came to the market almost 30 years ago and people were convinced that this would be the food of the future. However, several of these products have caused harm to health. People thus are again moving back to natural foods. Agro-business corporations are expanding their business. Starch, proteins, carbohydrates, phenols are still the best option for health in their natural state as found in natural food. Popping pills does not give the body all that it needs.

There is a strong movement against synthetic foods and demand for producing foods under natural conditions, preventing the loss of natural flavours. Naturopathy is one such movement and has a very convincing philosophy. It is practical and propagates natural fruit juice, vegetable juice, sprouted cereals and avoidance of overeating. The second strong movement is that of vegetarianism, which is against eating animal products. This is based on the premise that human beings are vegetarians by nature. The third movement is backed by customers who are keen to get nutritive food. There is a fourth group too, comprising those individuals who are part of contemporary cult, believing in ancient socio-religious thoughts that preach intake of natural food. Within these groups there are many sub-groups and individuals who have shifted to a more natural food intake.

Organic farming is gaining ground in developed countries. Food produced by modern methods like the use of artificial fertilisers and pesticides has proved to be harmful and is considered not to be as conducive to health as that

produced by natural cultivation. Organic farming enhances the cycle of growth, decay and rejuvenation of the soil itself and increases its fertility in the natural way. The final produce is also healthier for us as it does not have any toxic chemicals. One deterrent for people shifting to natural food, however, is its cost. The religion of a person is also an important factor that determines preferences in foods.

Foods that make human beings behave like animals driven by primal instincts are called *tāmasika* foods. *Rājasika* food generates an energetic and fighting spirit. The third type or *sattvik* food develops the gentle, generous and compassionate side of a person. The development of one's mental faculties is thus dependent on the type of food one takes.

The human body and mind have to adapt to various situations and adjust to the changing patterns of life. So, the progress made in the food industry may be of interest to many. But the shift from the present diet to a natural diet has to be gradual so that the body may not revolt. Principles of adaptation may help to solve this problem.

The quantity of food that a person takes depends upon the strength of *agni* or the anabolic process in the body. The quantity should be such that the food becomes part and parcel of the body. Heavy foods take more time to get digested than light ones. So, the quantity of food also depends upon the nature of the food being consumed. Food should strengthen a weak body and mind and destroy the causes of ill health.

In case of excess of certain elements in the body, reduction of the same elements becomes essential. Requisite reduction or addition in food intake is done by assessing the patient. The physician has to help create a balance in the supporting elements in the body. This process creates health, happiness and longevity. The *Caraka Sāṃhita* says the physician should be regarded as the bestower of blessings because he is responsible for health, happiness and longevity of all.

As far as compatibility with the body is concerned, there are substances that are against the properties of the body's supportive elements. Sometimes two kinds of substances are

incompatible when mixed, for example, lemon and milk. Similarly, certain things become beneficial when processed together. Some substances are harmful when eaten in certain geographic areas or region. For example, in dry sandy areas, rough, sharp and pungent substances cause illness. Climatic conditions should also be considered while eating substances. For example, in summer or when the weather is hot, pungent and spicy substances should be avoided. Some substances when taken together in equal quantity are harmful, such as honey and animal fat.

Therefore, the following factors should be considered while preparing and selecting foods in Āyurveda.

(a) Country, region (*deśa*)
(b) Time, climatic condition, age (*kāla*)
(c) Quantity (*mātrā*)
(d) Adaptation (*sātmya*)
(e) Bodily constitution (*vatādi doṣās*)
(f) Processing (*samskāra*)
(g) Metabolic end-produce (*vīrya*)
(h) Digestive condition of the individual (*koṣa*)
(i) Sequence (*krama*)
(j) Food after taking certain items (*parihāra*)
(k) Cooking (*pāka*)
(l) Integration (*samyoga*)
(m) Unripe or overipe articles (*sampada*)
(n) Procedure (*vidhi*)

These factors should also be taken into account while assessing compatibility of foods as well as drugs. Incompatible foods cause various diseases such as sexual inability, blindness, skin diseases, dropsy, boils, madness, fever, influenza, miscarriage, etc. The treatment is to eliminate vitiated matter from the body by vomiting, purgation, etc.

NIDRĀ (SLEEP)

Nidrā is the second pillar for longevity. Spiritually, sleep (*nidrā*) is considered to be an illusion (*māyā*) created by Lord Visnu.

Living beings get sleep naturally and it is attributed to various causes. According to the cause and state of sleep, names have been given to different types of sleep. When sleep occurs during annihilation of world (*pralaya*), living beings do not get up from *nidrā*. When sleep occurs equally well during the day as well as night, it is due to *tama*. People having *rajas* properties get sleep at night without any difficulty. Persons having less *kapha*, excessive vitiated *vāta*, and suffering from psychosomatic pains and weak constitution get faulty sleep. Persons of *sattvika* nature sleep at midnight. The majority of people and animals get up early in the morning to attend their natural and routine assignments.

Caraka Saṁhitā has described that when the mind is overpowered by *klama* (mental tiredness), the active soul gets tired. The individual withdraws from external objects of recognition and sleep sets in. Sleep is of seven types:

(a) *Tamobhava* (caused by ignorance)
(b) *Śleṣmasamudbhava* (caused by *kapha*)
(c) *Śarīraśramasambhava* (tiredness of body)
(d) *Manaḥśramasambhava* (tiredness of mind)
(e) *Vyādhyanuvarthini* (sleep due to disease)
(f) *Rātrisvabhavaprabhāva* (natural sleep at night)

Suśruta, the guru of Āyurveda, is of the opinion that consciousness resides in the *hṛdaya* (heart). When the *tāmasika* properties dominate, sleep is caused in living beings. The cause of sleep is *tama* (ignorance, inertness, etc.); *sattva* causes awakening.

It is stated by Suśruta that the Bhūtātma is the master, owner, or controller of sleep. Bhūtātma combined with *raja* properties confuses the mind with experiences that had occurred in the previous lives. *Tāmas* increases the confusion. Bhūtātma, the lord of sleep, appears to be sleeping but he is always vigilant. In other words, sensory organs are inactive during sleep due to *tama* and the normal cognitive process does not function. However, this is a deception because the deep subconsciousness never goes to sleep and is ever vigilant.

One should sleep in the daytime only when nights are of short duration. There are exceptions to this under certain conditions, such as in the case of small kids and old women, patients, who suffer from injury to chest, weak people who habitually drink wine, travellers tired after an arduous journey and people who perform physical labour without taking adequate quantities of food. People with shortage of blood, fat, sweat, *kapha*, etc. may also sleep in the day. Patients suffering from indigestion should not sleep even for a very short time during the day. Those who have not slept during the night can sleep for half a day.

In general, sleeping during the day is a fault according to Āyurvedic beliefs as all types of *doṣās* may be vitiated and vitiated *doṣās*, in turn, cause bronchitis, asthma, influenza, heaviness of head, body ache, anorexia, fever and lowering of metabolic rate. These problems and diseases can also be caused by not sleeping at night. This means that a person should sleep at night and in the right quantity. By doing this, the individual remains fit, healthy, happy, with good lustre, colour, and vitality. Such a person is neither fat nor weak nor thin. He is fit and healthy.

Loss of Sound Sleep

Āyurveda says that persons who do not sleep at the right time may have an imbalance of the inner elements. Vitiated *vāta* and *pitta* cause tension, weakness and loss of sleep. For these conditions, the treatment advisable is to restore balance by drugs that normalise the inner elements. Oil massage of the body in general and head in particular, specific application of medicated paste and pressing the body by special techniques are some treatments. Sweet, heavy and oily food should be prescribed. Wheat grains, *śāli* rice, jaggery, milk, and juice of certain meats and fishes are recommended. At night, dried grapes and unrefined sugar may be taken. Soft beds and seats are prescribed. Cars or other modes of travelling should be smooth.

Excessive Sleep

Predominance of *kapha* and *tāmasa* is the main cause of excessive sleep. To cure the problem of excessive sleep, the body in general and head in particular, should be purified. Patients may be given a purgative, emetic, nasal snuff, medicated smoking materials or medicated cigarettes. Physical exercise, blood-letting, uncomfortable bed, predominance of *sattva* and suppression of *tāmasa* are recommended.

Insomnia

The main reasons for insomnia are disturbed body metabolism and mental faculties, hatred, avarice, tension, overwork, old age, vitiation of nervous system, colic pain and loss of dear ones, etc. The patient can be cured by massage, soothing bath, soup of domestic, marshy and aquatic animals, curd, milk, unctuous substances, alcohol, use of fragrance and aromatic inhaling, sweet food, light and melodious music, kneading the body by hand, soothing the eyes, forehead and face, noiseless atmosphere, comfortable bed and home. The time schedule of sleep should be followed regularly.

Food should be taken as early as possible in the night. Light and easily digestible food should be taken at night. Curd should be avoided at night. Moderate reading may be done at night. While sleeping, artificial light should be avoided as much as possible.

Physiological and biochemical analyses may give details of the phenomenon of sleep. Imbalance of supportive tissues may also be investigated. Āyurveda considers sleep very significant for health and longevity.

BRAHMACARYA (CELIBACY)

Brahmacarya means avoiding marriage and preserving the semen for attainment of higher goals in life. Āyurveda and yoga have advocated the preservation of semen for good health. The importance of preservation of semen and leading

a bachelor's life for good health does not find favour with modern health promoters.

According to Āyurveda, semen is considered to be the cream of all the tissues and elements of the body. Loss of this vital fluid leads to loss of power, vitality and a cause for weakness of the immune system. It is also stated that married men too can also maintain good health and vigour, but they would need to restrict sexual activity. Thus, leading a married life with self-control on passions is also considered to be *brahmacarya*.

Yoga has attached highest importance to celibacy because it leads to uninterrupted progress in yogic practices. There are eight parts of yogic practices, which are:

(a) *Yama* or self-control
(b) *Niyama* or obeying the scriptural prescriptions
(c) *Āsana* or posture
(d) *Prāṇāyāma* or control of breath
(e) *Pratyāhāra* or withdrawal of senses
(f) *Dhāraṇa* or attention or concentration of mind
(g) *Dhyāna* or meditation
(h) *Samādhi* or deep meditation on Ultimate Reality

The first five are meant to discipline external entities, and are grouped under *bahiraṅga* or external forms. The other three are called *antaraṅga*, i.e. inner forms of yoga. Through these three inner forms, the disciples of yoga attain perfect union with inner self. But, the body has to be prepared first by *bahiraṅga*.

Yama, i.e. controlling oneself, consists of (1) observing non-violence (2) avoiding theft, (3) avoiding acquisitiveness, (4) truth, and (5) celibacy. *Brahmacarya* is placed under the category of *yama*, i.e. controlling the mind against various types of sexual indulgences. Not only loss of semen but even entertaining sexual thoughts, talk, touch, etc. are considered bad for health.

6

PRAKṚTI AND CONSTITUTION

There are numerous causes for the formation of a particular type of physical constitution. *Doṣās* play a vital role at the time of conception of an infant, during pregnancy, delivery of the child and subsequent growth. The psychic temperament of the individual is also decided by the three *doṣās*. The characteristic features of the body and mind remain with the individual throughout his life, but some changes may take place due to the unfolding of dormant characteristics. According to Āyurveda, the nature of the individual may be of seven types, viz.

1. *Vāta prakṛti*
2. *Pitta prakṛti*
3. *Kapha prakṛti*
4. *Vāta pitta prakṛti*
5. *Pitta kapha prakṛti*
6. *Vāta kapha prakṛti*
7. *Sama prakṛti*

CHARACTERISTICS

Vāta Prakṛti

The characteristics of *Vāta prakṛti* are (a) dryness and

roughness of the skin, tongue and body, (b) lean and thin body, (c) less height, (d) prominent tendons and veins, (e) dry, cracked and thin hair, nails, teeth, soles of the feet and palm, (f) brown hair with split ends, and (g) dry and rough eyes. *Vāta* has the attributes of non-unctuousness, lightness, mobility, abundance in quality, swiftness, coldness, dryness, roughness and instability.

Pitta Prakṛti

The characteristics of a person with *pitta prakṛti* are: (a) white colour of the skin, (b) dryness and tenderness of the body, (c) excessive black moles, (d) excessive sensitivity to heat on the face and extremities, (e) early signs of grey hair, baldness, and wrinkles, (f) hair with a reddish brown tinge, (g) slothness of muscles, (h) looseness of the joints, (i) bad body odour, (j) copper coloured nails, eyes, tongue, palate, palms and soles, (k) reddish small eyes with scant eyelashes. Attributes of *pitta* are hotness, sharpness, fleshy and pungent smell. The individual may have intolerance for hot things, having hot face and clear body. He will have excessive hunger and thirst, quick advent of wrinkles, baldness, etc.

Kapha Prakṛti

The characteristics of *kapha prakṛti* individuals are: (a) soft, tender and oily skin, (b) compact and muscular body, (c) corpulence, (d) fair complexion, (e) compact joints, (f) white eyeballs with red tinge at the outer corners, (g) black hair that may be curly, (h) prominent forehead, chest and arms, (i) nice, attractive and beautiful eyes with eyelashes in plenty. *Kapha* is unctuous, smooth, soft, sweet, slow, stable, firm, heavy, cold, viscous and clear. Accordingly, the individual may have these characteristics. Similarly, the quality of sweetness may increase the quantity of semen, desire for sex act and number of procreations.

Vāta kapha, vāta pitta, pitta kapha types of *prakṛtis* have a combination of respective qualities. *Sama prakṛti* indicates that the nature of the body is in a balance and characteristics are reflected accordingly. For therapeutic success, these

physical natures help in prescribing food, drinks and regimens that alleviate diseases.

Secondly, a person with *pitta prakṛti* may have more diseases caused by *pitta doṣā*. *Pitta prakṛti* diseases are also more troublesome and not easily curable as compared to those caused by the other two *prakṛtis*. Food articles that are sweet, cold and astringent are more suitable. In case of a *vāta prakṛti* person suffering from *vātika* diseases, hot and unctuous ingredients of food are recommended. *Kapha prakṛti* person suffering from a *kapha* disease should take hot, pungent, bitter medicines, food and drinks.

FACTORS FOR DETERMINATION OF *PRAKṚTI*

Physical constitution is determined at the time of conception, which depends upon the following factors:

1. The condition of the sperm and ovum.
2. The season, climate and condition prevailing inside the uterus.
3. Attributes of the food and regimen adopted by the mother during the period of pregnancy.
4. Nature of the evolved primordial entities.

Doṣās play a significant role in deciding the nature of an individual. The nature of any individual may also be moulded or nurtured by the following factors:

1. Caste by birth or by profession.
2. Family traits.
3. Locality and ecology.
4. Time, day, month, year and planetary position, at the time of conception.
5. Age of the parents.

CARE AND MANAGEMENT

Management of *Vāta Prakṛti*

Aggravated *vāta* is mostly due to certain food items. This may

result in impairment of strength, complexion, happiness and longevity. Following steps alleviate this *doṣā*:

1. Proper administration of oleation and fomentation.
2. Mild purgative prepared by the addition of fat, hot substances and substances having sweet, sour and saline tastes.
3. Food should also have sweet, sour and saline tastes.
4. Massage, poultice, bandage, kneading, effusion, bath, *samvāhana* (pressing and massaging by hand).
5. Use of wine and alcoholic drinks prepared by self-fermentation.
6. Fats mixed with digestive, stimulant, carminative ingredients are used for alleviating *vāta doṣā* and purgative tendencies. These oils should be boiled hundred to thousand times. These medicated fats may be used internally as well as for massage purposes.
7. Various types of medicated enema are best.

Management of *Pitta Prakṛti*

The principle is same. A person who takes in food causing *pitta* will have an aggravated *pitta*. This aggravated *pitta* may result in impairment of strength, unhappiness and reduced life. The following steps need to be taken:

1. Include *ghee*, animal fat in your diet.
2. Apply fat on the body.
3. Purgation is very essential.
4. Eat sweet, bitter and astringent articles of food, and items with cooling properties.
5. Use aromatic articles with mild, sweet, fragrant and cooling effects.
6. Use pearls, jewels and garlands and try to be, as far as possible, in air-conditioned places.
7. Use cold water medicated with *chandana* or sandalwood (*Santalum album*).
8. *Priyaṅgu* (*Callicarpa macrophylla*), *kaliya* (yellow variety of sandalwood), lotus stalk mixed with *utpala* (*Nymphaea alba*), *kumuda* (*Nelumbo nucifera*).

9. Listen to melodious music.
10. Keep company of young-at-heart friends.
11. Reside in a place that is cooled by moon's light, exposed to the breeze from north or east direction. River banks and high cold mountains are best.
12. Have aromatic flowers around you.
13. Use soothing, cooling and light clothes.

Management of *Kapha Prakṛti*

The aggravated *kapha* manifests *kapha* diseases and complaints such as impairment of strength, complexion, happiness and longevity. The following steps are needed:

1. Fatless diet, with ingredients having pungent, bitter and astringent tastes.
2. Exercise.
3. Indulge in plenty of sexual intercourse.
4. Have old wine with less water.
5. Indulge in therapies that reduce body fat.
6. Indulge in medicated smoking.
7. Use warm clothes.
8. Give up comfort and luxury.
9. Avoid sleep in daytime.

7

THE SEVEN
SUPPORTIVE ELEMENTS

Dhātu etymologically means 'that which enters in the formation of the basic structure of the body'. *Dhātu* comprises seven supportive elements or tissues. They are:

Rasa or the lymph/chyle.
Rakta or the haemoglobin fraction of blood.
Māmsa or muscle tissue.
Medas or fat tissue.
Asthi or bone tissue.
Majjā or bone marrow.
Śukra or the sperm in male and ovum in female.

All these seven tissues are constituted by the five great entities or *mahābhūta* but there may be a predominance of one or two entities in some tissues than in others, For instance, *pṛthvī mahābhūta* is predominant in muscle and fat issues. *Jala mahābhūta* is dominant in lymph and chyle. *Teja* or *agni mahābhūta* primarily constitutes the haemoglobin fraction of the blood. Similarly, the bone is composed of *ākāśa* and *vāyu mahābhūta* in excess.

It is to be emphasised that all substances are conceived to

be made of or constituted by the five basic entities and the difference is due to the predominance of a few of them in specific proportions. When the proportion of the entities changes, the equilibrium is disturbed, resulting in disease. *Mahābhūtas* are present in different proportions in different people. The original constituents should not be increased or decreased as that will disturb the natural equilibrium, and result in sickness.

However, it is a dynamic equilibrium and both internal and external factors may vitiate the *bhūtas*, and the proportion of *mahābhūta* in the specific *dhātu* may change, which is not desirable for the body. This change may appear in the form of an illness, requiring corrective measures.

EFFECTS OF VITIATED *DHĀTUS*

When different *dhātus* are affected, the symptoms are varied. Here is a description of the symptoms.

Rasa dhātu (vitiated)

Anorexia, bad taste in the mouth, nausea, heaviness, drowsiness, body ache, unconsciousness, change of complexion and gradual wasting of other *dhātus*. Aging starts earlier, with wrinkles and grey hair, and gradual wasting of body.

Rakta dhātu (vitiated)

Skin disease, pimples, haemorrhage through different channels of the body, enlargement of the spleen, abdominal pain, excessive black moles, ringworm, other skin diseases such as leucoderma, scabies, rashes, etc.

Māṁsa dhātu (vitiated)

Additional growth of unwanted muscular tissue in the form of granuloma, tumour, warts, tonsilitis, gangrene, skin diseases, goitre, etc.

Medas dhātu (vitiated)

Matted hair and dandruff, sweet taste in the mouth, burning sensation in hands and feet, dryness of mouth, palate and throat. It also leads to thirst, feeling of laziness, excretion of excessive sweat and other waste products, and numbness of the body.

Asthi dhātu (vitiated)

Increase in the size of bones (hypertrophy of bone), hypertrophy of teeth, fragile bones, pain in bones, change of complexion, faulty growth of hair and different diseases of hair and deformities of nails.

Majjā dhātu (vitiated)

Pain in finger joints, giddiness, fainting spells, deep-rooted abscess in the joints of fingers.

Śukra dhātu (vitiated)

Sterility, impotency, genetic deformity. Imbalance in parents could cause diseases in children.

CONCEPT OF *MALAS* (WASTE PRODUCT)

The human body is a living machine. The metabolic processes in the human body are involuntary in nature and go on without us being aware of them. During the formation of the seven *dhātus*, certain waste products are excreted from the body. Stool, urine and sweat are the most important waste products. Elimination of these toxins helps in maintaining good health in an individual. Most importantly, various diseases are caused due to improper discharge of stool, urine and sweat.

Discharge of stool and toxins helps in the growth of friendly bacteria in the colon, which in turn are needed to synthesise some useful body materials. On the other hand, accumulated stool gives rise to harmful micro-organisms. Urine is another waste product through which many body

wastes are eliminated. Thus, it is necessary to take enough water so that one passes urine at least six times during the day. Sweating is essential to maintain the correct heat balance in the body and preserve the skin, which protects the inner parts of the body. Proper exercise, yogic *kriyas*, fomentation, steam bath and certain drugs help the individual to sweat, getting rid of a lot of unwanted waste products. *Dhātus* or supportive tissues produce waste products during the process of metabolism. Physicians examine the various characteristics of the patient's urine and stool to diagnose the disease.

8

PREVENTIVE MEDICINE

Āyurveda's main purpose is protection of health or what one calls *swāsthya rakśā*. *Swāsthya rakśā* is an all-encompassing term. Not only does it cover the definition of *swāsthya*, i.e. health and ways and means for maintaining it, it also means preventing illness in the first place by removing those factors that disturb the equilibrium necessary for the well-being of the various organs, mind and soul. Therefore, *swāsthya rakśā* is a mean of achieving qualitative and quantitative requirements of *doṣas, dhātus, agnis,* and *malas.* Similarly, *swāsthya rakśā* of the society at large, or social health, is also an important aspect of the subject. Āyurveda considers that the world (*loka*) is also composed of a *śārīra* (body), *chitta* (mind or common consciousness) and *ātmā* (soul). Thus, it emphasises on social health as much as personal health.

Preventive medicine is one of the most important parts of Āyurveda. Prevention, as we all know, is better than cure, and Āyurveda provides us more ways than one to prevent diseases and take care of ourselves in such a way that we are always fit and happy.

Dinacaryā (behaviour during daytime)

Good or appropriate behaviour prescribed for daytime includes the following:

- After a good night's sleep, one should get up from bed early in the morning, before the atmosphere is disturbed by noise and other pollutants.
- Early morning is also the best time to pray to God or, if you do not want to do that, concentrate on one's own soul and subconsciousness. You will immediately notice more self-confidence and happiness.
- There should be realisation of self and programmes should be chalked out to achieve *dharma, artha, kāma,* and *mokśa.*
- The body and mind should be cleaned.
- Eyesight should be protected. Eyes must be splashed with cool water early in the morning.
- Plenty of water is to be drunk.
- You should take care to remove all waste products from your systems regularly.
- Teeth should be cleaned.
- Tongue should be thoroughly cleaned.
- Nasal drops are to be used.
- Pleasant things like cardamom should be chewed for good health.
- Gargling is prescribed.
- Oil is to be applied on head, if needed.
- Oil drops in ears, if needed.
- Oil massage on body is recommended at least once a week.
- Moderate exercise or yogic *kriyas* are required.
- Take a bath daily.
- Dress pleasantly in clean clothes.
- Use perfumes.
- Use ornaments.

- Take care of hair and nails.
- Use proper footwear.
- Eat healthy food with all the six tastes in it.
- Indulge in medicated smoking.
- Follow the codes of general civics.
- Study.
- Have a good professional conduct.
- Associate with good people.

Rātricaryā (behaviour during night)

- Proper sleep.
- Reading in the night is good but only in sufficient light. Reading material should also be light and easy on the mind.
- Moderate sexual relationship is recommended but only with the spouse.

Ṛtucaryā (behaviour during different seasons)

Details of seasons have been given earlier in the book. There are two solstices, called *ayanas* in Āyurvedic parlance. The *uttarāyana* (*ādāna kāla*) is the period of dehydration. It runs from the middle of January to the middle of July, comprising three seasons — late winter, spring and summer. The dehydration period is dominated by the quality of heat. *Dakṣiṇāyana* (*visarga kāla*) is a period of hydration. It ranges from the middle of July to middle of January, again comprising three seasons — rainy, autumn and early winter. In this period, winds are not very dry as they are during the period of *ādāna* or dehyration. The hydration period is like the moon, having cooling properties and soothing rays that delight the world.

Effects of Ādāna Kāla *(dehydration) on Body*

The body absorbs moisture during early and late winter, spring and summer. This enhances bitter, astringent and pungent tastes, causing weakness in the human body

Effects of Visarga Kāla (hydration) on Body

As the sun moves towards the south, rains absorb the heat of the earth. Herbs found during this time have sour, saline and sweet taste that cause unctuousness in the body. Strength begins to increase from the time of the rainy season as we move towards winter and again starts decreasing with the onset of the *ādāna* period (dehydrating period).

Ideal Diet for the Winter

During the winter, the body needs heat for proper digestion to take place so that nutrition from foodstuffs is absorbed and assimilated adequately. This then strengthens the immune system. An undernourished diet only vitiates the nervous system. It is natural for people to eat unctuous, sour and salty juices of the meat of aquatic and marshy animals containing fat during this period, but vegetables with proteins, such as pulses and dried fruits are more advisable. It is also advisable to regularly take cow's milk in its various forms, sugarcane juice, fat, oil, freshly harvested rice and hot water during the winter. Resorting to massage and application of oil on the head and residing in a heated room of the building is recommended.

We should wear warm clothes to keep our bodies warm or apply the paste or powder of *Aguilaria agallocha* Roxb. (*agaru*). Light food should be avoided. It is obvious that *hemanta* (early winter) and *śiśira* (late winter) is to be together considered as 'winter' here.

Ideal Diet for Spring

The accumulated *kapha* is melted by the heat of the sun, which may disturb the power of digestion and cause many diseases. *Kapha doṣa* is to be eliminated by emesis. Heavy, unctuous, sour and sweet diet should be avoided. Sleep during the day should be avoided. One should exercise, perform yogic *kriyas* and wash one's excretory organs regularly. Use of *candana, agaru* (*Aquilaria agllocha* Roxb.) both internally as well as externally as oils is recommended. Barley and wheat may be eaten.

Ideal Diet for Summer

During this period, all moisture gets evaporated by the sun's heat. Sweet, cold, liquid and unctuous food with sugar and *ghee* along with *śāli* rice may be taken to avoid dehydration. Water in any form should be consumed. One should avoid a salty, sour, pungent or hot diet. Physical exercise may also be avoided, and instead, some yogic *kriyas* may be done in the mornings. One should sleep in the open or in a cool place. Sprinkled water and fresh breeze should be enjoyed every morning. Gardens and flowers are to be enjoyed. It is advisable to be moderate in diet and other activities. Meat of goat and moving ouside in the sun should be avoided. Intake of honey in meals and drinks is recommended.

Ideal Diet during Rainy Season

During the heavy rainy season, take conspicuously sour, salty, unctuous diet and drinks. This is to avoid vitiation of the nervous system. Vegetable soup, old barley wheat and *śāli* rice along with purified water or rain-water may be taken. Regular bath and wearing fragrant garlands during this season is advisable. One should avoid humidity but should wear light and clean apparel.

Ideal Diet for Autumn

After the comparatively cool rainy season, the body experiences heat during autumn, which results in the accumulation of *pitta*. Hence food and drinks that have the potential to alleviate *pitta* are to be taken in proper quantity when one is hungry. Rice, barley and wheat are recommended. Bitter medicated *ghee*/animal fat, purgation and blood-letting are also recommended. Sunbath, oil, meat of aquatic and marshy animals and alkaline salt preparations and curd along with food may be avoided. Sleeping during daytime and exposure to frost and easterly winds should be avoided. Water that is purified by the sun during the day and detoxicated by star canopy (*agastya*) in the night is to be taken. This water is like nectar for the purpose of bathing, drinking

and swimming. The rays of the moon in the evenings are exceedingly beneficial.

NATURAL URGES

There are two types of urges experienced by all individuals, which should ideally be attended to properly. The first includes those urges that should not be suppressed and the second, those that should be. Urges that are not to be suppressed should be attended to immediately as delay may lead to a disease.

Non-suppressible Urges

- Urination
- Defecation
- Sexual intercourse
- Vomiting
- Sneezing
- Yawning
- Hunger
- Thirst
- Tears
- Sleep
- Breathing

Suppressible Urges

- Rashness and evil deeds.
- Physical, mental and verbal misdeeds.
- Greed, grief, fear, anger, vanity, shamelessness, jealousy, and malice.
- Speaking harsh words, gossiping, lying and use of untimely words.
- Violence, adultery, theft and persecution.

It is said that a person free from all suppressible urges is a saint and can attain true happiness. He alone enjoys the fruit of virtue, wealth and desire, i.e. *dharma, artha* and *kāma* respectively.

9

ADAPTATION

Āyurveda is the science of living beings adjusting to internal and external forces and the changing patterns of our ecological set-up. An individual's ecological universe is the reflection of the great universe. Hence, changes affecting the universe also affect individuals.

There are three main stresses causing change in individuals:

- *Ādhibahautika* - related to environmental stresses.
- *Ādhidaivaka* - related to providential causes
- *Ādhyatmika* - related to psycho-somatic causes and disturbances.

These assaults or *abhigātas* may be explained in terms of physio-chemical sciences. These assaults may be from other living forms as parasites, etc. These may be meteorological and climatic crises or other physical forces that operate upon individuals, in terms of mass and volume (*ādhidaivika*). Man destroys the jungle and other natural balances which cause (*ādhibhautika*) stresses.

These mould an individual's personality and make it suitable to the person's surroundings.

Adaption or *sātmya* to change caused by the different stresses may be developed. The process of adaptation is

voluntary or conscious in the beginning. Subsequently, it becomes involuntary and human beings adjust themselves without actually being aware of it. For example, chemicals are widely being used to boost vegetable and animal production and to protect them from pests. These chemicals were never ingested by humans earlier but they gradually got used to them. The capability of the human body to adapt to these changes can also be described as *sātmya*. Different people can thus interpret *sātmya* differently.

Good habits lead to a healthy way of life. Toxic or unhealthy diet, drugs and strange behaviour may also be adapted to achieve some specific and desirable results. It then becomes wholesome for that individual.

Sātmya has a limited role in diagnosis of diseases. It leads to happiness by restoring the balance of supporting tissues and plays a vital role in restoring the constitutional balance.

Inference is a tool used in Āyurveda to know *sātmya*.

The different kinds of *sātmya* are:

Ṛtu sātmya: This is adaptation to different climatic conditions.

Roga sātmya: This is adaptation to diseases. Immunity plays a vital role in the prevention of diseases. Similarly, adaptation against diseases can be developed.

Deśa sātmya: The ability to adapt to a place, country or region is called *deśa sātmya*.

Udaka sātmya: This is adaptation to water. Water is an essential element for living beings. Hence, the importance of water in *sātmya* or adaptation cannot be ignored.

Jāti sātmya: Communities have some peculiar traits that influence the formation of *jāti sātmya* or adaptation of community.

Divasvapana sātmya: This is adaptation to improper behaviour. Some individuals or living beings adapt themselves in such a manner that improper behaviour, diet and drugs do not harm or effect them. An example is that of a person who sleeps during daytime without any complaint afterwards.

TYPES OF *SĀTMYA*

From the practical point of view, *sātmya* is of two kinds:
 (a) *Prakṛta sātmya* (natural adaptation)
 (b) *Oka sātmya* (acquired adaptation)

Prakṛta sātmya

This pertains to a human being adapting according to his genetic characteristics. This varies due to various factors such as heredity, constitutional frame of basic elements, metabolic adjustment, mental development, family, tribe, community, country and race. Due to weakness in natural adaptation techniques or lack of a certain type of *sātmya*, some diseases can be caused which are termed as *adibala-pravṛtta* (hereditary factor) and *janmabala-pravṛtta* (natal factor). It is observed that the body acquires the requisite adaptation as it grows and certain causes and diseases become harmless. Individual immune system becomes strong enough to prevent any harmful manifestation.

Oka sātmya

This is a systematic process of acquiring certain characteristics that help the individual to adapt to strange surroundings or food, etc., or behave normally despite having abnormalities.

DEVELOPING *SĀTMYA*

There is a systematic approach to removing or acquiring a particular type of *sātmya*. The gradual elimination of undesirable things and addition of desirable ones are followed step by step. Through this, the whole course may be divided into four or as many intervals as required. However, any abrupt change in habit or diet may prove to be fatal. Specific types of adaptation come into play when professionals are trained, like astronauts, military personnel and even police dogs. In olden days, it was this kind of specialised training and adaptation that developed the *viṣakanyā* – poisonous women for ending the lives of kings or enemies. They acquired poison in their systems by taking it in small doses regularly.

10

MINERALS AND INORGANIC DRUGS

Āyurvedic treatment has four components: (1) physician, (2) drugs, (3) patient, and (4) nurse. There are three natural sources of drugs. These are (1) vegetable kingdom, (2) animal kingdom and (3) mineral and organic drugs. It is a known fact that mercurial and inorganic elements are less popular and their descriptions are fleetingly mentioned in original classical texts. The first reference about inorganic elements in *Caraka Saṁhitā, sutra* 1;69 is very significant in this respect.

Survarṇam samatāḥ pañcalohāḥ sasikatāḥ sudhāḥ |
Manaḥ-śilāle maṇayo lavaṇam gairikāñjane | |69 | |

Caraka Saṁhitā, Sutra 1;69

Gold, five *lohas*, i.e. silver, copper, tin, lead and iron, *sasikatā* (silicon), *sudhā* (calcium), *manaḥsila* (realgar), *hartāla* (yellow arsenic), *gairika* (ochre) and *añjana* (antimony) are *pārthava dravyas*, i.e. these are derived from earth. Cakrapāṇi stated in his commentary *Pṛthivīvikāraḥ Parthivam*, that these are transformed matter on the earth. This leads to science of matter.

SCIENCE ABOUT MATTER

The words *samalaḥ* and *vikāra* have special significance. *Samalaḥ* refers to the formation of by-products during

metabolism called *malas*, while *vikāra* refers to transformation of matter into substances. For example, when milk turns into curd, the curd is said *vikāra* of milk.

EVOLUTION OF THE EARTH

It may not be out of context to describe here the formation of earth according to our ancient literature. It was postulated that the *hathāsa* of Ādi Lord Śiva caused *ādi śabda*, i.e. primordial sound (word) in the form of a great laughter. From it followed the origin and evolution of the universe. It may be noted that Ādi Śiva was Creator of all conceivable entities which were explained in a personified way. So, the Brahmā, Viṣṇu and Maheśa — the Trinity were also created by Ādi Śiva or Svayambu.

It is stated in modern science that in the first fractions of the second after the 'big bang', matter and radiation was formed. Minutes later, hydrogen (H_2), deuterium (D), and helium (He) were born. Heavier elements had to await the formation and processing of these gases within the stars. This is exactly what was perceived in ancient classics. From *ākāśa* to *vāyu*, then *jala, agni* and *pṛthvī*; this evolution is called *pañcamahābhautic* evolution. Heavy elements like iron were made in the cores of star, while stars that end their lives as explosive supernovae produced much heavier elements.

The planets of our solar system probably formed from a disc-shaped cloud of hot gases, the remnants of a stellar supernova. As the early earth formed something like its present mass, it heated up due to radioactive decay of unstable isotopes and partly by trapping energy from the other planets. This melted iron and nickel, and their high densities allowed them to sink to the centre of the planet forming the core. Subsequent cooling allowed solidification of the remaining material into the mantle of magnesium (Mg), iron (Fe), and ozone (O_3) compositions. This is what the *Caraka Saṁhitā* stated in *Sutrasthāna* 1;69.

The primitive atmosphere was composed of carbon dioxide (CO_2) and nitrogen (N_2) with some hydrogen and

water vapours. Evolution of the modern oxidised atmosphere did not occur until life began to develop.

The production of oxygen during photosynthesis had a profound effect. Initially, the oxygen (O_2) was rapidly consumed, oxidising reduced compounds and minerals. However, the rate of supply of O_2 exceeded consumption of O_2 and it began to build up in the atmosphere. The primitive biosphere, mortally threatened by its own poisonous by-product (O_2), was forced to adapt to this change. It did so by evolving new bio-geo-chemical metabolisms, which support the diversity of life on the modern earth.

The centre of Mendeleyev's periodic table is occupied by nine metals, i.e. iron, nickel, cobalt and six metals of the platinum groups. Heavy metals take up considerable space to the right of nickel and platinum. These are copper, zinc, silver, gold, lead, bismuth, mercury and arsenic. Miners look for them in lodes, which cut through the earth's crust. These are useful in Āyurveda and most of these metals had been mentioned to explain *pārthiva dravyas* in *Caraka Saṁhitā*.

THE ESSENTIAL MINERALS

The beauty of the *śloka* given at the beginning of the chapter lies in indicating *sasikatā* (granite), which is the basis of earth's crust. Granite contains about 80 per cent silica or 40 per cent silicon. But, even long before man learned to use silicon dioxide for his needs, Nature had made extensive use of it in the life of plants and animals. The second metal is *sudhā* (calcium). It refers to calcareous rock. Third substance or rather third category is *maṇayo* (carbonaceous deposits); fourth one is *lavaṇa*, which refers to acidic and alkaline substances or rock-like acids, granite, rhyolia, intermediate rocks like diorite and basic rocks like basalt. For antimony, the authority has indicated *añjana*. It is known since antiquity.

The *malas* of five *lohas* lead to sedimentary as well as metamorphic rocks. Sulphur played an exceptional role in the process of volcanic activity or formation of mountain

ranges and lodes. *Haritāla*, a compound of sulphur and arsenic, is indicated in the *śloka*.

Oceans and mountains play a vital role. The explanation given in the form of symbolic representation to common people is the story of *Samudra manthana*, i.e. churning of the oceans with a mountain by both devils and gods. The big snake used around the mountain signifies life. Churning the ocean with a mountain represent bio-geo-chemical metabolisms. Devils and gods represent negative and positive forces; action and reaction; radioactive action and ions, etc.

AGE OF THE EARTH

Physicists and chemists figured out that 1,000 grammes of uranium would yield 13 grammes of lead and 2 grammes of helium in 100 million years. On the basis of these data, geo-chemists and geo-physicists had recently drawn up an absolute chronological scale of the geological evolution of earth. The new time-table tells us that the age of our planet probably exceeds 3,000 to 4,000 million years, i.e. 3,000 to 4,000 million years have elapsed since the time earth were formed.

A terrestrial environment consists of solids (rocks, sediments and soils), liquid components (river, lakes and groundwater) and biological components (plants and animals). Reaction of these three leads to changes in the composition of each category of reservoir.

Mud, silt and sandy sediments are formed mainly due to weathering, the break down and alteration of solid rocks. The sediment is usually transported by rivers to the oceans. In sea-water, the sediment sinks to the sea-floor where physical processes and chemical reactions convert it to sedimentary rocks. Eventually, these rocks become land again, usually during mountain building. New sedimentary rocks are derived either from the older sedimentary rocks or from the newly generated or ancient igneous and metamorphic rocks.

Natural water bodies such as rivers, lakes and ground water act as polar solvents, and organisms, particularly plants and

bacteria, influence the types and rates of chemical reactions, which occur in soils and water bodies.

The above description is not complete in itself. It only suggests the part played by various terrestrial components. Some of the present-day mountains were earlier ocean floors. So, in the rocks of these mountains, we still find fossils of sea-plants and animal remains.

Śilājitā is a unique example of this. Its solubility in water further confirms that it is a best example of knowing the formation of rocks, minerals and elements which had been stated by Caraka Mahaṛṣi in his *Saṁhitā* at *sūtra* 1; 69. *Śilā* in general means rock. The product of a rock is called *śilājitā*. In this connection, Cakrapāni, in his commentary, had stated that the aim was to give a brief account. One has to find the details from other classics.

RASA ŚĀSTRA

Nagarjuna was a very famous authority on the use of mercury and other minerals as well as inorganic elements. His slogan was *Siddhe rase kaṛṣyāmi nirdaridra yamidam jagat*, meaning that he would make this world free from poverty by attainment of absolute control over Mercury. There were two schools of thoughts. One school concentrated on bringing out therapeutic properties of mineral and inorganic elements. This school was remembered by the name *Deha-Siddhi*, i.e. to achieve expertness for the betterment of body of the individual. The second school was called *Loha-Siddhi*. Under this, the basic metals are changed into heavy metals such as gold and silver. This process is also known as alchemy.

The transmutation of metals was very popular with chemists of the world. Whether this trend was borrowed from Āyurvedic *Rasa Śāstra* or whether it was western alchemy that influenced Āyurveda in the eighth century AD is a subject matter of research. *Rasa Śāstra* was praised because medicines acted very quickly. The dose was very small, and as the drugs were very costly, these mercurial preparations attracted the rich patients.

Many annual and seasonal herbs become unavailable if the monsoon fails. So, the drugs from mineral origin became more dependable than preparations of vegetable origin. It is to be remembered that Āyurveda includes everything with certain modifications as drugs.

Similarly the scope for selecting drugs has been widened by *Caraka Saṁhitā Sutrasthāna* 1 that says, *Tadeva yuktam bhaisajyam yadārogyāya kalpate* — the right medicine makes for health.

Classification of Preparations

Under *Rasa Śāstra*, the preparations can be classified as follows:

Rasa: *Rasa,* i.e. mercury, is a main ingredient of the preparations of *Rasa Śāstra.* It is considered to be the semen of Lord Śiva, signifying the power and potency of positive forces. Sulphur is considered to be the menstrual blood of Pārvatī, wife of Śiva. It represents negative forces. Union of negative and positive forces is a must for complete and excellent preparation. So, the compound of mercury and sulphur in given proportions is prepared as a base for other mercurial preparations.

Loha: Metals like gold, silver, copper, iron, tin, lead, zinc and alloys like brass and bell metal.

Uparasa and sadhanarasa, i.e. minerals and chemicals:
- *Abhraka* (Black mica)
- *Vaikranta* (Tourmaline)
- *Makśika* (Chalcopyrite)
- *Vimala* (Marcosites)
- *Shilājita* (Black bitumen; mineral pitch)
- *Sasyaka* (Copper ore, mostly of copper sulphate)
- *Chapala* (Ore of selenium/bismuth)
- *Rasaka* (Calamine)
- *Kāntā* (Load stone)

- *Gairika* (Ochre)
- *Kāsisa* (Ferrous sulphate)
- *Tuttha* (Copper sulphate)
- *Tuvari* (Alum)
- *Gandhaka* (Sulphur)
- *Hartāla* (Orpiment)
- *Manḥshila* (Realgar)
- *Nilañjan* (Galena)
- *Gauripashama* (White arsenic)
- *Navasadara* (Ammonium chloride)
- *Nāga Sindura* (Red oxide of lead)
- *Hiṅgula* (Cinnabar)
- *Muddarśriṅga* (Calcium sulphate)
- *Godantū* (Calcium sulphate)
- *Nāgapāśāṇā* (Serpentine)
- *Karpardikā* (Cowrie sea-shell)
- *Ratnas* (Gems and valuable stones)
- *Manikya* (Ruby)
- *Muktā* (Pearls)
- *Prāvala* (Coral)
- *Tarkshya* (Emerald)
- *Puṣaprāga* (Topaz)
- *Vajra* (Diamond)
- *Nila* (Sapphire)
- *Gomeda* (Cinnamon stone –hessonite)
- *Vaidurya* (Cat's eye)
- *Rajāvarta* (*lapis lazuli*)
- *Suryakānta* (Sunstone)
- *Chandrakāntā* (Moonstone)
- *Akika* (Agate)
- *Lavanāni* (Various salts)

STANDARDISATION IN ĀYURVEDA

It may be stated that standardisation had been emphasised from the very beginning, when Āyurveda was conceived, learned and expanded; theory and practice were explained to the future generation of physicians as well as to interested individuals. It is not a new concept. *Caraka Saṁhitā* has described this concept of standardisation in detail. One entire section consisting of eight chapters was included on the subject with aphorisms. This section is named *Vimāna sthāna*, i.e. the place where principles and their related subjects, objects and functions are given with special reference to specific measurements or rational evidences.

Caraka Saṁhitā is not confined to laying down standards of single and compound drugs. It explains all questions pertaining to the criteria of determination, judgment and assessment of various salient characteristics of Āyurveda vis-a-vis standardisation.

It may be relevant to mention that *Caraka Saṁhitā* is a compilation of various seminars or conferences related to various topics. Authorities at that time participated in discussions and their views are reflected in the treatise. Therefore, the eight chapters of *Vimāna sthāna* are the

outcome of the combined effort of prominent scholars and authorities on standardisation. Its value can be estimated in the light of the quantitative evaluation of the substances.

Āyurveda follows the theory of cause and effect. It is represented with valid, logical corollary. Every physician thinks that disease is a suffering, i.e. etiology of the disease. The cause of suffering can be known through *pañcha nidāna* or the five ways to diagnose a disease. It is also said that there is a way to restore health by restoring the lost balance of various elements of the body.

All knowledge can be reduced to numbers. There is no such thing as a quality that cannot be quantified. Quality is a mere myth or ignorance. Everything can be explained in terms of chemistry, physics and mathematical understanding. Hence, reductive methodology was not unknown to Āyurveda.

Commenting on the significance of the word *vimāna*, Cakrapāṇi stressed that '*vi*' stands for the special emphasis on the determination of measure of various essential principles of Āyurveda. Measurement presupposes the problem of fixing a standard, which is needed. A substance must have properties and functions to be performed by it. In order to fix the standards of the drug, it is essential to know the terms: *rasa, guṇa, virya, vipāka,* etc. In respect of treatment, the physician must know the causes of the disease, early signs and symptoms, actual signs and symptoms, drug or treatment. Relief-providing substances, food, behaviour, techniques, methods, alternatives, strength and weakness analyses, time factors and other details in respect of etiology, pathology and diagnosis should be followed.

After knowing these factors, the pharmacology of *dravya*, vitiated basic elements of the body, degeneration, medicine, country (region), constitution or physique, climatic conditions, strength of drug, food, physical characteristics due to predominance of one supportive element and adaptation, mind, nature and age, etc. are to be analysed. While knowing the measures against disease, it is also necessary to know the types and varieties of the factors under consideration.

AREAS OF STANDARDISATION COVERED

Rasa (tastes) are six: sweet, acidic, salty, pungent, bitter and astringent. Each taste has been explained in the first chapter of the treatise. These details may be termed as Āyurvedic pharmacology. Adaptation and foods have been dealt separately with the same details. Nature of substance and its processed forms must be known to find out its actions on the body.

The second chapter provides details on food nutrition, dietetics, metabolic process, etc.

The third chapter deals with epidemics. Social hygiene and preventive medicine have been highlighted under this topic. Various factors like abnormal seasonal fluctuation, violence, war and other demerits of human race are responsible for lowering the standards of medicine. Ethical dictions given in the chapter are eternal in nature. Truth-fulness, clarity, right conduct are essential for maintenance of standards in human dealings or enterprises.

The fourth chapter relates to epistemological issues such as direct observation, inference, reasoning and directives of authorities. Reductionism, synthetic approach, rationality and other scientific methodologies have been explained.

The fifth chapter is really a description of the measures of various systems pertaining to circulation. Metabolic pathways of human body and other channels — macro and micro — have been given in detail. Microbiology has been explained from the functional point of view.

This chapter also deals with psychiatry. Psychiatry in Āyurveda should be reoriented with reference to various terms such as *dhṛti, mana, vijñāna, moha, krodha, śoka, dainya, harṣa, love, bhāgyam, dhairyam, virya, śraddhā, medha, saṅgya, smṛti,* etc. The possible equivalents of the above terms have not been given because each needs comprehensive details.

The sixth chapter deals with the specific standards of nomenclature of disease. Details have been provided to classify and name the unknown diseases depending upon the vitiation

and damage caused. A standard physician is he who knows all the diseases and their cure.

Government titles and regulations of medical practice and surgery had been in vogue in ancient times, very similar to the present-day councils formulated through statutory acts. The expert who knew all the diseases, types of drugs and rendered the services with distinction was honoured by the king as *Prāṇapati* or master of life.

The seventh chapter has been named as *Vyadhitarupiyam Vimāna*. It is stated that there are two types of patients. The first has a positive attitude despite suffering from a severe disease. The second type of patient feels he would not live long despite suffering from a minor disease. The physician thus should not be led astray with mere appearances. Patients and diseases should be assessed correctly. This chapter recognises the role played by micro-organisms, and deals with their classification and treatment therefore.

The eighth chapter is named *Rogābhiṣagjitīyam*. In the beginning, it is stated that the rational human being should know the depth of a subject, whether it involves heavy work or light work, etc. Proper action should be done at the right time, at the right place and for the right cause. Accordingly, reason should guide individuals in selecting their disciplines of learning, texts, teachers and other related aspects.

Ten types of examination have been stated for proper understanding of the patient and disease. These are:

- Examination of system or text.
- Examination of teacher for teaching Āyurveda.
- Examination of student.
- Methodology of study.
- Methodology of teaching.
- Mutual discussion or dialogue.
- Forty-four procedures of discussion or debate.
- Ten causes of action.
- Purification of body and mind.

There are many texts available to physicians in the

academic world. Selection should be based on the quality of book. The knowledge should enlighten the intellect just as the bright sun dispels darkness. Further, the criteria for selection of a teacher are specific. A teacher should be an expert in teaching and imparting training; he or she should be well versed and knowledgeable regarding other systems and contemporary practices.

Students should obey and follow the directions of the teacher. The teacher is like fire, king, father or master, so he will bestow all good blessings for excellence in the student's scientific pursuit in the field of medicine and surgery. Āyurveda considers the teacher as a protector or nourisher. He gives a second birth to his student. After the completion of studies, students are considered as another caste. *Caraka Saṁhitā* gives details in respect of teaching, reading or studying or dialogues with equally qualified physicians.

There is no end to Āyurvedic knowledge. It should be studied continuously without negligence and distraction. A physician should observe celibacy and chastity. He should obey his teacher except in the matter of killing living beings. He should revolt against the established government for taking harmful actions. He should not praise his own achievements and attainment of scientific knowledge. He should not find faults in other people but try to imbibe their good qualities. The whole world is a teacher for wise people. The wise man should follow the righteous course and practice as to provide benefits to the suffering humanity

DEBATE

For arriving at right, good and correct conclusions, dialogue or debate with equal experts is needed. Healthy discussion is possible where there is an understanding of compromise and friendship. This is named *sandhaya sambhaṣā*. Unhealthy discussion with the intention of winning over the other debator is called *vigṛhya sambhaṣā*. This is an argument for the sake of argument, while *sandhaya sambhaṣā* is an enquiry

or search for finding a solution to the problem, and not to exhibit supremacy over the other debating authorities. The first debator should be enriched with knowledge and science possessed by the second arguer. He should politely submit his viewpoint. The second debator should take part without the fear of being defeated or humiliated. The debate should enrich the intellect through combined efforts.

There are some concepts which are to be known for a debate. These are:

- *Vāda* (debate). A discussion based on evidences and logics is called *vāda*. It should be within the limit of the following five elements:
 - *Pratigyā* (oath or logical proposition)
 - *Sthāpanā* (establishing)
 - *Hetu* (cause)
 - *Udāharaṇa* (example)
 - *Upanaya* (application of established facts)
 - *Nigamana* (conclusive argument)
- *Dravya* (basic substances)
- *Guṇa* (properties)
- *Kārma* (action)
- *Sāmānya* (similarities)
- *Viśeṣa* (specialities)
- *Samavāya* (concomitances)
- *Pratigñā* (logical proposition)
- *Sthāpanā* (establishing logically)
- *Pratisthāpanā* (establishing logically against established fact)
- *Uttara* (reply)
- *Dṛṣṭānta* (example understood by both wise and unwise persons)
- *Siddhānta* (established truth after many types of examinations)

 This established truth arrived at by performing many tests is of four types:
 - *Sarvatantra siddhānta*: Agreed to by all scientific systems.

- *Pratitantra siddhānta*: Agreed to by specific scientific systems.
- *Adhikaṇa siddhānta*: Establishing related truths or theories, while approving the one main established truth.
- *Abhyupagama siddhānta*: The truth, which was not established through tests, causes and authorites, agreed upon for the sake of arriving at certain facts (factors) under consideration.
- *Śabda* (word). Oral or written word. Here, the written words are of four types:
 - *Dṛṣṭārtha:* Words or sentences denoting events experienced by the individual.
 - *Adṛṣṭārtha:* Words or sentences not experienced by the individual, such as *mokśa* or liberation.
 - *Satya:* Truthful sentences.
 - *Anṛta:* False sentences.
- *Pratyakśa* (direct observations by soul, mind and cognitive organs)
- *Anumāna* (inference)
- *Aitihya* (authoritative statement or discourse)
- *Upmāna* (simile)
- *Saṁśaya* (doubt)
- *Prayojana* (purpose)
- *Savyabhicara* (leading towards doubt)
- *Vyavasāya* (a stage of certainty)
- *Arthaprāpti* (gaining meaning)
- *Sambhava* (possibility)
- *Anuyojya* (faulty sentence)
- *Ananuyoja* (the sentence without any fault)
- *Anuyoga* (one participant wanting to know all from others)
- *Pratyanuyoga* (one participant keeps repeating the pragmatic cause)
- *Vākyādoṣa* (one debator goes on finding faults in sentences)
- *Nyūna* (giving limited explanation)
- *Adhika* (giving uncalled for explanation in details)

- *Anarthaka* (words that do not communicate any meaning)
- *Apārthaka* (each word has a meaning but does not convey any meaning in a sentence)
- *Viruddha* (any sentence that is against simile, principle and time) Accordingly, there are three types of time. One is called Ayurvedic time, second is known as *yāgnika* time and the third is termed as *mokśaśā* time.
- *Chala* (a sentence that cheats the debator)
- *Ahetu* (something that appears as a true cause but is not really so)
- *Pakaraṇasama hetvābhāsa* (appears to be the real cause with reference to the subject under consideration)
- *Ahuta hetvābhāsa* (non-cause of any subject stated in such a way that it serves the purpose of removing doubt of identifying the factors)
- *Varnyasama hetābhāsa*
- *Atītakāla* (time that has passed but is stated as though it is yet to come or it is stated first when it should have been stated afterwards)
- *Upālambha* (stating faults of causation)
- *Parihāra* (removing faults of causation)
- *Pratigñāhāni* (loss of the first point of discussion)
- *Abhyanugñā* (acceptance of merits and demerits)
- *Arthānatara* (one is expected to state one specific subject but he states another subject)
- *Nigrahasthāna* (the point when the debate gives way to defeat)

This procedure of finding the true reality of cause or of any aim and objective has been explained for the benefit of medical as well as non-medical personnel. But, physicians should definitely debate or have dialogues on Āyurveda.

INVESTIGATION

For acquiring knowledge, the following items must be

investigated:

- *Kāraṇa* (causative factors for effect)
- *Karaṇa* (instruments)
- *Kāryayoni* (transformative factors)
- *Kārya* (action)
- *Kāryaphala* (result of action)
- *Anubandha* (bondage)
- *Deśa* (base, area of action)
- *Kāla* (time)
- *Pravṛtti* (inclination for action)
- *Upaya* (methodology, means)

These should be examined before starting any action or treatment.

Kāraṇa

Proper examination may be done by (a) direct observation and (b) inference for assessing the root cause of the disease. For the physician, nurse, drugs and patients themselves are causative factors for effects.

Karaṇa

Anything or action that restores equilibrium of supportive elements is *karaṇa*. These are of several types with reference to dependence: (i) *daivavyapaśraya* and (ii) *yuktivyapaśraya*.

Daivavyapaśraya consists of

- *Mantra*
- *Oṣadhi dhārana* (intake of drugs)
- *Maṇi dhāraṇa* (wearing of stones)
- *Maṅgala kriya* (performing auspicious actions or rituals)
- *Bali pradana* (scacrificing living beings)
- *Upahāra* (offering)
- *Homa* (ritual sacrifice, i.e. offering in front of a fire)
- *Niyama* (religious observance)
- *Prāyaścita* (penance)
- *Upavāsa* (fasting)

- *Svastyayana* (benediction)
- *Praṇipāta* (prostration, salutation)
- *Gamana* (voyage, etc.)

Yuktivyapāśraya is treatment conducted with rational approaches and is of three types: (i) purification, (ii) sedative, (iii) surgery. These exhibit clear results.

Auṣada (drug) under *yuktivyapāśraya* is of two types with reference to organs:

- Material drugs based on substances.
- Non-material drugs or schemes or measures. These are of different types such as (a) fear-causing devices, (b) surprising effects, (c) forgetfulness, (d) *kṣobhana* (excitement), (e) *harṣaṇa* (causing laughter), (f) five arrows of Cupid, such as *kṣobhana, harṣaṇa,* etc., (g) *bhartsana* (reprimand), (h) *vadha* (violence), (i) *bandha* (act of fastening), (j) *svapna* (dream), (k) *samvāhana* (hitting by fist), etc.

Kāryayoni and Kāryaphala

Action to establish equilibrium, which results in happiness of mind, intellect, cognitive organs and body as well as soul.

Anubandha

Age is termed as *anubandha.*

Deśa

The field of action is called *deśa. Deśa* is of two types: (a) land and (b) patient. Land is investigated with reference to birthplace and residence of patient, place where he falls ill, the type of food, life and customs followed by people of that region. Attitude and adaptation of patient as well as the type of vitiation of elements are to be diagnosed. Similarly, habitat of medicinal plants are to be examined. It is also essential to examine the intensity of disease and the potency of medicine. Both are to be proportionately adjusted.

Kārya or Examination

In order to know the strength of the patient and its quantitative

assessment, the following factors have to be evaluated:

- *Prakṛti* (nature)
- *Vikṛti* (pathology)
- *Sāra* (basic strength of patient)
- *Samhanana* (constitution)
- *Pramāna* (quantity)
- *Sātmya* (adaptation)
- *Satva* (mental faculties)
- *Āhāra śakti* (strength due to food)
- *Vyāyāma śakti* (strength due to exercise)
- *Vaya* (age)

Prakṛti or nature of the patient is mostly genetic in nature. It involves pregnancy, sexual harmones, sequences, nature of uterus, food and behaviour of mother, and nature of the five great *bhūtas*.

Vikṛti is disturbance and imbalance of *doṣās*, i.e. *vāta, pitta* and *kapha*.

Sāra of patient is to be examined while keeping in view all the the eight types. These are as follows:

(a) *Tvaksāra:* The skin is a dominant factor in these individuals. Skin is oily, smooth, delicate, tender, clean, fine and having deep delicate hair on the body. It is shining and lustrous in appearance. This indicates that persons have happiness, luck, grandeur, intellect, education, health, pleasure and longevity.

(b) *Raktasāra:* When blood dominates, it is called *raktasāra*. Blood is a source of power in this type of person. Ears, eyes, mouth, tongue, nose, lips, palms of hands, soles of feet, nail, brain, forehead, urinary organs are oily, red, beautiful and bright in appearance. Persons with this type of *sāra* are happy, cruel, intelligent, emotional, delicate and possess relatively less strength. They can bear sorrow but cannot tolerate heat.

(c) *Māmsasāra:* Persons having *māmsasāra* strength are muscular in nature. Their forehead, neck, eyes, checks, jaws, shoulders, abdomen, armpit, chest, hands and feet are heavy

and muscular in appearance. Fortitude, tolerance, lack of temptation, wealth, education, happiness, gentleness, health, strength and longevity are indications of persons having this *sāra*.

(d) *Medahāra:* Persons having excessive corpulence of body are seen to possess unctuous complexion, voice, eyes, hair, nails, lips, urine and faeces. They possess wealth, grandeur, happiness, fineness and need soft treatment.

(e) *Asthisāra:* Their bones, nails and hair are firm and stable. They are very courageous, dynamic, and tolerant of worry, have stable body and long life.

(f) *Majjāsāra:* These people derive their strength from the bone marrow. Their organs are thin and powerful, they have unctuous complexion and voice, and joints are long, dense and thick. They have longevity. They are bestowed with wealth, children, power, knowledge of texts and science, and honour.

(g) *Śukrasāra:* These people get their strength from sex hormones. They are gentle, embodiment of peace and politeness, have attractive personality, their eyes radiate satisfaction and brightness, their minds are very happy. Their sexual power is more than normal. Teeth are unctuous and well formed. Complexion and voice are clear. They are liked by the opposite sex. They like enjoyment and excessive consumption. They are powerful and possess happiness, wealth, children and honour.

(h) *Manaḥsāra:* These people get their strength from the mind. They have good memory. Courageous, expert and brave, they fight very vigorously in any battle. They do not have tension and worry. Their intellect and desired actions are very much deep in nature. They are ready to do good for others.

It is to be mentioned that persons possessing all types of *sāra* are strong, honourable, reverent, noble, tolerant, dynamic, do good to others, possess strong and compact body, and power, wealth and happiness. It is to the credit of Āyurvedic principles that measurement of each part of the body has been given. One can examine each individual

accordingly.

Sātmya (*adaptation*) is one of the factors for examination. Mind is also to be examined. There are three types of minds: i.e. (i) *pravara sattva*, (ii) *madhya sattva*, and (iii) *avara sattva* as per the strength.

Ahāra-śakti is the power generated by food. Metabolic process is to be examined.

Vaya (age) is to be examined as per various stages of attainment of a long life.

Kāla or Time

Time can be divided as per the requirements into six climates, two apparent solar movements called *ayana*, three seasonal characteristics, i.e. (a) *śita*, (b) *uṣṇa*, and (c) *varsā* (winter, summer and rainy seasons). There are many ways to understand the measurement of time. Knowledge of various climates is a prerequisite of the main therapeutic actions such as the five means for purification of body.

Pravṛtti

This relates to the four kinds of examination of the patient: clinical, psychological, socio-economical and pharmacological.

Upāya

All the above means and techniques can be considered under *upāya*.

Our sacred voyage through the fathomless ocean of knowledge has enriched us with excellent material expounded in a rational way. Determination of standards through mathematical calculations has not been touched because the scope of this book is to introduce the treasury of Āyurveda.

It is a bold and original attempt on the part of those eminent scholars, sages of the yore and savants to grasp and to comprehend as much as possible of the natural world and arrange the knowledge into phenomenal sequences and events in relation to the Ultimate Reality. Knowledge has been

defined from the point of view of its causes and measures, as well as according to its systematic classification pertaining to all things including abstract notions of *doṣās*. These have been standardised rationally, systematically and these are to be quantified further. These aspects from mathematical angles are not covered due to scope of this book.

12

GENETICS AND
ĀYURVEDA

For many centuries scientists were keen to know what living matter was made of. Analyses led them to cells, which were considered fundamental units of life. Cells are complex microscopic bags of chemicals, surrounded by a thin and flexible cell membrane, which is responsible for holding the contents of the cells, controlling the entry of nutrients into and sending waste products out of the cells. Some plants and microbial cells have a rigid outer wall.

Living matter can produce copies of itself without any direction from outside. The capacity for self-perpetuation is taken as the definition of life. Lifeless matter cannot produce another matter like itself. According to Āyurveda, the body is composed of extremely tiny units, which are countless in numbers. These units are called *paramāṇu*. These cannot further sub-divide without the risk of their ceasing to exist as units of life. Āyurveda, in its authoritative classical book, *Caraka Saṃhitā, Śārīrasthāna* Chapter 7; 18 has acknowledged cells, which are many in number, microscopic in nature and possess very subtle sense organs. Their union or separation is caused by *vāyu*. Their actions are spontaneous. It is further explained that the body has numerous parts and these parts are perceived

as one organic whole. This is called *saṅga* (organisation).

With the union of *paramāṇus*, the whole organic system works with the help of the power of *vāyu*. A cell is in union to achieve a fixed target. After achieving the target, a natural separation is caused due to feeling or knowledge of non-attachment. With separation, which is a stage of *āpavarga*, self-perpetuation of cells is over. This leads to the stage of liberation. The cell gets separated from the act of producing its progeny. Curiosity is over. So, the wonderful dance of cell is also over. Simultaneously, the conscious entity is free.

For achieving any complex structure, the cells need both *yantra* and *mantra*. The *yantra* is the cell and its components. The aphorismic plan or *mantra* is the genetic information, which is same for every cell located anywhere in the body. The genetic information determines the distinguishing features of all organisms. Development of cells into parts and their growth depend upon the design and plan of the five basic elements.

Biotechnologists transfer genetic information into one cell from another. The receiver cell decodes the information and reproduces the function of the original cell. This technique of knowing the blueprint of life and interpreting it gives power to biotechnologists to draw up the design of organisms with new functions and attributes.

Cellular symbiosis, i.e. a mutually beneficial interaction between two organisms, also plays a vital role for generation of the powerhouse of eukaryotic cells, called mitochondrion. The mitochondria are considered to be the first organelles in cells. The second organelle descended from symbolic prokaryote, and is the chloroplast available in plants.

DIŚĀ

Human genetics plays a vital role in promotion of health, prevention and cure of diseases as well as in correcting deformities. This means that physical mapping under powerful microscopic study is necessary to know the physical signs and

posts generated by *pañcamahābhūtika* (five primordial entities) structures. The total genetic stuff is made of the supportive substance called *kapha* which is present in the biological *paramāṇus*. Physical mapping is needed to know *diśā*, which is one of the nine basic *dravyas*, with reference to DNA present in the nucleus and mitochondrial genome. Space is a prerequisite of *diśā*. Actually, *pañcamahābhūtas* or their representive *vāta*, *pitta* and *kapha* play natural roles in various proportions and dominance of proto-elements. Evolution takes in *kāla*.

There are four bases in DNA, each containing carbon and nitrogen atoms arranged in rings. These are adenine (A), guanine (G), cytosine (C) and thymine (T). ATGC may be taken as the four *mahābhūtas* requied for looking into genetics in Āyurvedic parlance. Space or *ākāśa mahābhūta* is everywhere and hence, the remaining four *mahābhūtas* are responsible for tremendous varieties of living beings by modifications or evolutions during the period of biological time (*kāla*). Thus, differences are generated due to fruits of specific actions, as *Nayāya Darśana* says: '*Vyakti bhedaḥ kārma viśesāt*'. There is nothing constant except constant change. So, the study of the sequence of changes is to differentiate an individual from individuals, a group from other ethnic groups. This leads to comparative studies of genomes.

A study of the macro and micro *srotas* in *paramāṇus* helps us to understand normal and abnormal states of cells. This is to be achieved through *pañcamahābhūtika* mapping. Epistemological study of the five great primordial entities may explain the grammar of the human body, mind and soul.

From the Ultimate Reality, the universe came out in perfect wholeness; in a complete form with undifferentiated similarity in nature, actions and other known or unknown characteristics. This is akin to the reproduction of an amoeba which takes place by a simple division caused by an external stimulus. The new amoeba is exactly like its parent without any difference.

Pūrṇamadaḥ pūrṇamidam
Pūrṇātpurnamudacyate
Pūrṇasya pūrṇamādāya
Pūrṇamevāṣiśyate
 -*Bṛhadarānyaka Upaniṣad,* 5th *adhyāya,* 1st *Brahmana,* 1st *mantra*

(The universe that originated from completeness is complete in every respect. After imparting completeness, the original complete being remains complete, just as it was before creating the new units.)

There are many comprehensive concepts, ideas, universal and eternal basic principles in Āyurveda and traditional knowledge to draw parallel paradigms for understanding eternal knowledge. Once these basic parallels are drawn, then functional genomics, its application in the treatment of diseases, creation of an eco-friendly atmosphere, prevention of psychosomatic diseases, socio-political harmony and removal of economic disparity can be devised to their logical ends.

Cloning was known in *Tretā yuga.* Goddess Sītā gave birth to a son who was named Luva. Muni Viśwamitra, in whose heritage she took shelter after Lord Rama sent her to the jungle, on not seeing Luva for some time thought that he was missing. As it would be a great shock and tragedy to Sītā, he was very much perturbed. He created a boy who was similar to Luva. After a while, Sītā came with Luva and was surprised to see another boy exactly like her son. The Muni realised his misadventure of creating Kuśa. This cloning episode was stated in the sacred book *Rāmāyana.* Kuśa or *Eragrostis cynosuroides* (*desmostachya bipinnata*) is a grass belonging to Family *Graminaeae* that was used by the Muni as a base material for that. It was the scientific methodology to evolve a human being from a plant. In *Dvāpara yuga,* Kauravas' birth as hundred children occurred outside the womb of the mother from a lump of flesh. It appears that cloning was practised prior to *Kali yuga.*

It may be stated that there is a great scope of incorporating āyurvedic concepts in modern genetics. These may be in the fields of prokaryotes, eukaryotes, codified and non-codified repetitive sequences of DNA, satellite bands, variable number tandem repeats, RNA, old eugenics and new eugenics, etc.

13

DRAVYA-GUṆA— THE SCIENCE OF DRUGS

D*ravya-guṇa* is a term used for describing drugs (*dravya*), and their properties and action (*guṇa*). Actually, the definition of *dravya* is related to *karma* (action) and *guṇas* (properties). These two reside as concomitant factors, and are intrinsic qualities of *dravya* (substance). The scope of *dravya-guṇa* covers the following aspects of drugs:

• *Pharmacognosy:* Systematic studies of nomenclature and identification of drugs of vegetable and mineral origin. In Āyurveda, various names and synonyms for drugs cover morphological characters of herbal and mineral drugs.

• *Pharmacology:* It is a science of properties and actions of drugs.

• *Therapeutics:* It is a science of experiments based on properties and actions of drugs. It describes the uses of drugs in diseases, the dosage and vehicles. Diet and other allied aspects are covered because these also help to cure diseases.

• *Pharmacy:* Storage and collection of drugs, various processes by which the *dravya* (substance) becomes a drug for administration in a disease. This covers the basic principles and fundamentals relating to *dravya* and is the edifice of the

science of drugs and its allied aspects. The five *mahābhūtas* constitute the animal body as well as vegetable and mineral kingdoms, from which drugs are derived. The similarity between and uniqueness of different drugs and body tissues constitute the basic background for selecting and describing certain items for preservation of health and curing of diseases. Action of drugs has been categorised into (a) those that increase body weight, and (b) those that decrease body weight and strength. If there is similarity in action, properties, and constitution of the drug with the body tissues, it causes increase in body weight; contrary to this, dissimilarity causes decrease in weight.

Epistemologically, it is not possible to have more than five sense organs and there are not more than five basic entities to be perceived. Five is thus an important number. If there is chaos and disturbance, the dynamic equilibrium changes into an imbalance of supportive elements. This results in a state of pain, termed as 'disease'.

CLASSIFICATION OF DRUGS

It is to be followed that the evolution of each entity has been envisaged for the formation of the universe. Accordingly, the *bhūtas* (atomic state), *mahābhūtas* (gross state) and *dṛsya bhūta* (material state) are *pañcabhautika* at the gross level. Living beings that die are devoid of consciousness, and they turn back into the basic *pañcabhautika*. Hence, Āyurveda at *dravya* level prescribes *pañcabhautika* substances as drugs. These are classified in various ways as per their utility, as given below:

Categorisation as per Source

These are of three types:

- *Audbhida* (plant products)
- *Jāṅgama* (animal products)
- *Pārthiva* (minerals like mercury, iron, etc.)

Plant products are of four types:

- *Vanaspati:* Big trees and those having fruits (but no apparent flowers). Examples are coniferous plants.
- *Vānaspatya* or *vṛkśa:* Medium-sized trees bearing both flowers and fruits, such as mango, *amla,* etc.
- *Virud:* Shrubs and weak plants.
- *Oṣadhi:* Medicinal plants such as *citraka, aśwagandhā.*

Similarly, the animals source of *jāṅgama dravyas* are of four types:

- *Jarāyuja:* mammals
- *Aṇḍaja:* birds, fishes
- *Swedaja:* insects
- *Udbhijja:* frog, earthworm

These classifications may be improved upon on the basis of biological divisions. Nevertheless, the divisions of animate sources indicate the scientific and systematic approach through direct observations and their availability in Nature.

Categorisation as per Use in Treatment

Dravyas are either meant for diet (*āhāra*) or to be used as a drug. Drugs may be either very gentle and light in potency or very strong.

Categorisation as per Effect

The third division is based upon the effects on *doṣās, dhātus,* etc. Examples are given below:
- *Doṣā-praśamana* or *pradūsana* (*doṣā* pacifier or vitiator).
- *Dhātu-praśamana* or *Pradūsana* (*dhātu* pacifier or vitiator).
- *Swastha-kara* (maintainer of health).

Categorisation as per Therapeutic Applications

The fourth category is based on the therapeutic applications. The two major applications are: (a) *saṁśamana* (pacifier) and (b) *saṁśodhana* (purifier). Purification is further classified into *vamana* (vomiting), *virecana* (purgation), *asthāpana* and

anuvāsana (stablishing and nourishing enema), and *sirovirecana* (snuff).

Categorisation as per *Caraka*

Caraka Saṁhitā first explains *dravya* and then gives 50 groups of drugs according their therapeutic actions. Each group contains 10 drugs that are termed *mahākasāyāḥ*-decoctions. It is possible to increase the drugs in each group, taking into account the common characteristics of that group. Similar drugs may enrich the scope of the drugs of vegetable origin. These groups are given below:

- *Jīvanīya* (vitaliser)
- *Bṛaṁhaṇīya* (weight promoting)
- *Lekhanīya* (curative)
- *Bhedanīya* (disintegrating)
- *Sandhānīya* (healing)
- *Dīpanīya* (appetiser)
- *Balya* (strength promoting)
- *Varṇya* (complex promoting)
- *Kaṇṭhya* (beneficial for throat)
- *Hṛdya* (beneficial for heart)
- *Tṛptighna* (destroyer of satisfaction)
- *Arśoghna* (anti-haemorrhoidal)
- *Kuṣṭhaghna* (anti-dermatosis)
- *Kaṇḍūghna* (anti-pruritic; removes itching, irritation and even scabies)
- *Kṛmighna* (anthelmintic; kills macro and micro worms/insects)
- *Viṣaghna* (anti-poison)
- *Stanyajanana* (galactogogue; increases the quantity of female breast's milk)
- *Stanyaśodhana* (galactodepurant; purifies female breast's milk)
- *Śukrajanana* (semen promoting)
- *Śukra śodhana* (semen purifying)
- *Snehopage* (sub-oleative)

- *Swedopaga* (sub-diaphoretic; mild drug for sweating)
- *Vamanopage* (sub-emetic)
- *Vivecanopaga* (sub-purgative)
- *āsthāpanopaga* (sub-corrective enema)
- *Anuvāsanapaga* (sub-unctuous enema)
- *Śirovirecanopaga* (sub-errhines; light snuffing)
- *Chardinigrahaṇa* (anti-emetic)
- *Tṛṣṇānigrahaṇa* (anti-dypsic)
- *Hikkānigrahaṇa* (anti-hiccup)
- *Purīṣ saṅgrahaṇīya* (astringent)
- *Purīṣa virajaṇīya* (faecal depigmenter)
- *Mūtrasaṅgrahaṇīya* (anti-diuretic)
- *Mutra virajanīya* (urinary depigmenter)
- *Mūtra virecaṇīya* (diuretic)
- *Kāsahara* (anti-cough)
- *Śwāshara* (anti-asthma)
- *Śwayathuhara* (anti-phlogistic)
- *Jwarahara* (antipyretic)
- *Śramahara* (fatigue reliever)
- *Dāhapraśamana* (regrigerant; removes burning sensation)
- *Śitā praśamana* (that which provides warmth)
- *Udarda praśamana* (anti-allergic)
- *Aṅgamarda praśamana* (anti-bodyache)
- *Śūla praśamama* (intestinal antispasmodic)
- *Śoṇitasthāpana* (haemostatic)
- *Vedanāsthāpana* (analgesic)
- *Sañjñasthāpana* (resuscitative)
- *Prajāsthāpana* (anti-abortifacient)
- *Vayaḥsthāpana* (gerontologic)

The whole exercise is to promote health and longevity by starting with a vitaliser and ending with *vayaḥsthāpana*, i.e. having a long life.

Categorisation as per *Suśruta*

Suśruta has arranged drugs as per the prominent drug in the group for specific diseases. For example, the *Jivanīya* group of *Caraka* is *Kākolyādi gaṇa* of Suśruta. In this group, *Kakoli* is

being projected as the typical representative drug. Two examples are given instead of all the groups.

- *Vidārigandhādi gaṇa* is used for removing vitiated *pitta* and *Vāta*, gaseous tumour, emaciation, lassitude, dysnoea and cough.
- *Āragvadhādi gaṇa* is meant for vitiated *kapha*, poison, diabetes, skin diseases, fever, vomiting, ulcers.

Categorisation as per Physical Qualities

A classification is based on physical qualities such as *madhura varga, pañcakola, pañcatikta,* etc.

Categorisation as per *Bhautika* Composition

This group is based on the *bhautika* composition of drugs on the basis of the predominance of a certain *mahābhūta*. Drugs are grouped as *pārthiva, āpya, taijasa, vāyavya* and *ākāśiya*.

A rational approach has been adopted while categorising drugs on the basis of the predominance of the *bhūtas*. In every substance, there are all the five *mahabhūtas* but one of these five *bhūtas* is active and dominant as compared to the other *bhūtas*. When there is loss of water in the body, substances having enough water are administered. For stimulating the digestive system, substances having the *agni* element in excess are given. For reducing weight and bulkiness, *vāyavya* drugs are used, and in order to clear the metabolic channel, *ākāśiya dravyas* are used.

1. *Pārthiva dravyas:* These have smell, *madhura* and slightly *kaṣāya rasa*. Their properties are *guru, khara, kaṭhina, manda, sthira, visada, sāndra* and *sthūla*. Due to their taste and properties, they promote growth, weight, compactness, stability, strength and purgation.

2. *Āpya dravyas:* These *dravyas* are predominantly sweet, astringent (slightly), sour and salty. They are also cold, oily, slow moving, heavy, liquidity, delicate and slimy. These drugs cause moistening, oleation, binding, and are pleasing in nature.

3. *Taijasa dravya:* These drugs have a bright and radiant

look, are pungent, slightly sour and salty in taste. They are
hot, sharp, irritant, dried, rough, light and non-compact,
causing burning, digestion, lustre in complexion,
illumination, tearing, heating, upward motion (causing
vomiting).

4. *Vāyavya dravya:* Sensation of touch is predominant.
Taste is astringent and slightly bitter, microscopic in nature,
rough, cold, light and non-compact. These cause non-
sliminess, lightness, lassitude, roughness, and the movements
are quick.

5. *Ākāśiya dravyas:* Sensation of sound is more than other
sensations. Taste is not obvious. Smooth, microscopic shape,
tender, quick, spreading, compact and discriminate in nature.
These substances are soft, porous and light.

RASA OR TASTE

Rasa is sensed by the tongue. Taste indicates composition,
properties and probable action of the drug. *Rasa* in Āyurveda
also stands for mercury, and is the first element of the seven
dhātus.

There are six *rasas.* These are caused by a combination of
mahābhūtas as given below:

Rāsa	Taste	Caused By
Madhura	Sweet	*pṛthvī* and *āpa*
Amla	Sour	*pṛthvī* and *tejas*
Lavaṇa	Salty	*jala* and *tejas*
Kaṭu	Pungent	*vāyu* and *tejas*
Tikta	Bitter	*vāyu* and *ākāśa*
Kaṣāya	Astringent	*vāyu* and *pṛthvī*

The composition given above is the one proposed by
Caraka Saṁhitā. Suśruta is of the view that *amla* is composed
of *jala* and *tejas* and *lavaṇa* is composed of *pṛthvī* and *tejas.*
The difference in outlook does not have any appreciable
importance in respect of practical application. These
compositions are known through the inference drawn on the
basics of their effect on the body. For example, *madhura rāsa*

increases *guru* and *snigdha guṇas*. These *guṇas* increase *kapha doṣā* and decrease *vāta* and *pitta doṣās*. *Kaṭu rāsa* increases *vāta* and *pitta* and pacifies *kapha*. From this, it may be inferred that *kaṭu rasa* is composed of *vāyu* and *tejas*. *Madhura rasa* increases *kapha* because of the predominance of *pṛthvī* and *āpa* in both entities. *Tikta rasa* pacifies *pitta* and as such has no *tejas*. Now, *tikta rasa* increases *vāta* and decreases *kapha*, which indicates the predominance of *vāyu* in its composition. By rational thinking and inference, other combinations can be evaluated systematically and scientifically.

The concept of *anurāsa* has been conceived because *dravyas* do not have just a single *rasa*. Apart from the predominant *rasa*, all the other rasas are called *anurasa*. In the process of testing, the main *rasa* is perceived first and *anurasas* are perceived at the end. For example, *haritakī* has got five *rasas*, out of which *kasāya* is predominant. This is the main *rasa* while the other four are *anurasas*. Another popular example is that of *rasona* (garlic). It has five *rasas* but *kaṭu* is predominant. The others are subservient and thus they are *anurasas*.

There are 60 combinations of *rasas* in *dravyas* and these combinations correspond to the 60 combinations of *doṣās* in the body. So, the application of *rasas* has been systematised.

Water has no *rasa* when its comes from the sky (*ākāśa*). It reaches the soil (*pṛthvī*) where it gets nutrients in the form of chemicals to plants. The plants are consumed by animals. *Jala* element includes different types of liquid. For assessing *rasa*, the *jala* element is needed and this is an inherent property of *jala*. One *rasa* may be transformed into another *rasa* due to various factors such as time, type of container, combination, heat, place, contamination, chemical reactions, etc.

Kaṭu (pungent), *amla* (sour) and *lavana* (salty) constitute one group called *agneya* (burning *dravyas*). The second group comprises *madhura* (sweet), *tikta* (bitter) and *kasāya* (astringent) and is called *saumya* (soothing *dravyas*). *Agneya* increases *pitta* while *saumya* decreases the *pitta*. All digestives contain *agneya* substances. In jaundice and internal

haemorrhages, substances having *saumya rasa* are prescribed.

As the *rasa* is a subject of 'likes', there are four types of *rasas* as per their effects and 'popularity'. These are:

- *Swādu hita* (tasteful and wholesome)
- *Swādu ahita* (tasteful and unwholesome)
- *Aswādu hita* (distasteful and wholesome)
- *Aswādu ahita* (distasteful and unwholesome)

As a thumb rule, some *dravyas* which are bulk-reducing are called *chedanīya* (*laṅghana*). Some are bulk-promoting and are called *upaśamaniya* (*bramhaṇa*). Some *dravyas* are ordinary in nature and are called *sādhāraṇa rasa*.

Madhura Rasa

Madhura rasa is pleasant and softening. It has *snigdha* (unctuousness), *śitā* (coldness) and *guru* (heaviness) properties. It is pleasing, good for the brain, healing, relieves burning sensation, removes thirst, beneficial for heart, throat, skin, increases secretion of milk in females and acts against poison. It promotes growth, strength and complexion. It alleviates *pitta* and *vāta*. It is soothing, invigorating and nourishing; it brings stability in equilibrium.

When it is used in excess, it causes vitiation of *kapha* resulting in fat formation, laziness, heaviness, loss of appetite, loss of the power of digestion, cough, fever along with cold. Many diseases of excessive *kapha* are enumerated. These are connected with the various lymphs, tonsils and eyes, etc.

Amla Rasa

It immediately causes salivation, sweating, burning sensation in the mouth and throat, and is a good appetiser. It has the properties of unctuousness, heat and lightness. It increases *kapha*. As such, it has a pleasing, appetising, digestive and anticoagulant action. It causes thirst disorders due to excess of *pitta*, laxity in muscles, dropsy, inflammation and burning sensation.

Lavaṇa Rasa

It has a salty taste. It is unctuous, hot and heavy. It has the properties of curing indigestion. It is digestive and harmful to semen. It increases *kapha* and *pitta* and reduces *vāta*. Disorders caused are impotency, grey hair, falling of hair, haemorrhage, gastritis, skin disorders.

Kaṭu Rasa

It is a pungent *rasa*. It is dry, cold and light in properties. It is mouth-cleaning, appetiser, digestive, bulk-reducing, anthelmintic, useful in dyspepsia, increases *vāta* and *pitta* and decreases *kapha*. It may cause impotency, unconsciousness, vertigo, debility, burning sensation and thirst.

Tikta Rasa

It is dry, cold and light in properties. It is a digestive, anthelmintic, appetiser, antipyretic, anti-poison. It increases *vāta* but decreases *pitta* and *kapha*. Excessive use may cause emaciation, debility, vertigo, dryness of mouth, nervous diseases.

Kaṣāya Rasa

It is dry, cold and light. It is an astringent, absorbent, healing, and harmful for semen. It increases *vāta*, decreases *pitta* and *kapha*. It causes dryness of mouth, cardiac pain, tympanitis, constriction in channels, impotency and nervous disorders.

The descriptions of *rasas* here are illustrative ones.

GUṆA

Guṇa may be taken as a qualification of the *dravya*. It is a causative agent and a *dravya* devoid of *guṇa* has no action. *Guṇas* have been classified into four categories:

- *Guṇavādi* (physio-pharmacological): 20
- *Parādi* (para-pharmacological): 10

- *Viśista* (specific): 05
- *Ādhyātmika* (spiritual): 06

Gunvādi Guṇas

Guṇavādi qualifications are used in pharmocological description. These are as follows:

- *Guru* (heavy)
- *Laghu* (light)
- *Manda* (dull)
- *Tikṣṇa* (sharp)
- *Śita* (cold)
- *Uṣṇa* (hot)
- *Snigdha* (unctuous)
- *Rūkṣa* (dry)
- *Slakṣṇa* (smooth)
- *Khara* (rough)
- *Sāndra* (solid)
- *Drava* (liquid)
- *Mṛdu* (tender)
- *Kathina* (hard)
- *Sthira* (stable)
- *Sara* (movable)
- *Sūkṣma* (micro)
- *Sthūla* (macro)
- *Viśada* (compact)
- *Picchala* (slimy)

These are the physical qualifications. In the context of digestion, *laghu* means that which is easily digestible. Heaviness denotes not only weight but also that which is very hard to digest.

Parādi Guṇas

These qualifications are useful in pharmacy and medicine. These are:

- *Para* (preferable)
- *Apara* (not-preferable)

- *Yukti* (rational)
- *Sāṅkhya* (enumeration)
- *Samyoga* (conjection or combination)
- *Vibhāga* (division, disintegration)
- *Pṛthaktava* (separateness)
- *Parimāna* (weight and measures)
- *Saṁskara* (impression due to processing)
- *Abhyāsa* (regular practice)

Viśista Guṇas

- *Śabda* (sound)
- *Sparsa* (touch)
- *Rupa* (vision)
- *Rasa* (taste)
- *Gandha* (smell)

Adhyātmika Guṇas

These are the spiritual qualities.

- *Buddhi* (intellect)
- *Icchā* (desire)
- *Dweṣa* (aversion)
- *Sukha* (pleasure)
- *Duḥkha* (pain)
- *Prayatna* (volition)

It may be observed that *guṇa* supersedes the *rasas* and changes the resultant action. For example, water may increase the *kapha* owing to its natural sweetness but the same water, if heated, may decrease the *kapha*. It is also observed that *guṇa* helps *rasa* to strengthen its action. *Āmalakī* is taken as the best *dravya* from *amla rasa* but this is due to its *mṛdu* (tender) and *śitā* (cold) *guṇas*. *Guṇa* also influences *vipāka* (metabolites). Hot, dry, light and porous qualities generate *laghu vipāka*. Utilities of *guṇa* are more than that of *rasa*.

VIPĀKA

The whole process of digestion through all the stages is called

awasthāpāka. The digestion at the end stage is called *niṣṭhāpāka.*
Awasthāpāka produces *doṣās* as *malas* and can be seen. On the
other hand, *nisthāpāka* produces *doṣās* as *dhātus* and can only
be inferred. The word *vipāka* or special digestion conveys the
meaning 'special cooking'. It occurs after the normal round
of digestion is over.

Suśruta is of the opinion that *vipāka* is of two types, i.e.
laghu (light) and *gur* (heavy). *Caraka* takes three *vipākas,* i.e.
madhura (sweet), *amla* (sour) and *kaṭu* (pungent). *Madhura* is
equal to *guru* i.e heaviness and *kaṭu* and *amla* are equal to
laghu (lightness); *vāta, pitta* and *kapha* stand for *kaṭu, tikta*
and *madhura* respectively.

Effects of *Vipākas*

Vipāka is based on the *pañcamahābhūta.* During digestion,
the predominance of *pṛthvī* and *jala* may give rise to *madhura*
vipāka or *guru vipāka* remaining as three *mahabhutās,* i.e. *agni*
(fire), *vāyu* (air) and *ākāśa* give rise to *kaṭu* or *laghu vipāka.*
Madhura vipāka behaves like *madhura rasa* in its effects. *Amla*
increases *pitta* and decreases semen. *Kaṭu vipāka* increases *vāta*
and causes constipation and anti-diuretic action.

Difference between *Rasa* and *Vipāka*

It is pertinent to know the differences between *rasa* and *vipāka.*

Rasa	*Vipāka*
1. It is felt on the tongue.	It is a metabolic transformation.
2. Immediate response.	Delayed response.
3. Effect is localised.	Systematic effect.
4. Psychological response is immediate.	It may or may not generate pschological, logical response or feeling of well-being.
5. Perceivable directly.	Perceivable through intermediation.

Rasa and *vipāka* play similar roles.

VĪRYA

Vīrya is considered as the potency with which the drug acts.
Vīrya is more dominant in drugs while *rasa* is more dominant
in dietary substances.

Caraka Saṁhitā is of the view that the presence and absence of active priniciples should be observed. For example, a specific part of a plant may give more powerful results than the whole plant. Similarly, the processed drug may attain more potent effects than the same drug in an unprocessed form. This is the law of *Anvaya-Vyatireka*. It is also observed that certain qualities increase the *vīrya*. By inference, eight qualities have been shortlisted that activate the potency of the drug. These are: (a) *laghu*, (b) *guru*, (c) *śīta*, (d) *uṣṇa*, (e) *snigdha*, (f) *rukśa*, (g) *mṛdu*, and (h) *tikta*.

In Āyurveda, the beauty of understanding lies in generalisation. So, *vīrya* has been divided into two: *śīta* (cold) and *uṣṇa* (hot). These two potencies represent negative and positive potent forces or actions.

KARMA

Karma is translated as action. But, in the context of Āyurvedic pharmacology, *karma* is that which causes *saṃyoga* (conjunction) and *vibhāga* (disjunction), irrespective of any other factor and is located in *dravya*. The action on organs, *doṣās, dhātus* and *malas* for restoring the dynamic equilibrium or homeostasis of the person is called *karma*. It may be taken as the response of the living tissue to *dravya*.

The mode of action of drugs is based on the theory of *pañcamahābhūtas*. Each organ, *doṣā*, etc. of the body are composed of these five *mahābhūtas* in different proportion. The means of correcting imbalances in the body are also composed of the five *mahābhūtas*. The specific situation of the body is corrected by the actions of *dravyas* composed of the *pañcamahābhūtas*.

Actions may be general or localised; these may be direct or indirect. For example, the pungent action of *kaṭu rasa* on the tongue is direct, while the increase in excretion from eye, mouth, nose, etc. is due to reflex mechanism, which is considered indirect. The actions of drugs have been classified. The *Caraka Saṁhitā* has described 50 groups of drugs

according to their actions. New drugs can be added accordingly.

The principle of generalisation has been adopted and *karmas* have been grouped into two categories. Firstly, the *saṁśodhana* and *saṁśamana* (purification) is done by five systematic *karmas*, i.e. *vamana* (vomiting), *virecana* (purgation), *āsthāpana* (stabilising enema), *anuvāsana* (nourishing enema or unctuous enema) as well as *nasya* (taking drugs through the nose). The *saṁśamana kārmas* may again be grouped into six, such as *snehana* (oleation), *rūksana* (roughening or creating roughness), *bṛṁhana* (weight gaining), *laghana* (bulk decreasing), *swedana* (heating or sweating) and *stambhana* (cooling).

There are numerous actions mentioned in Āyurvedic texts. Some important actions are enumerated here:

Nervous System	Name of Drug
• *Medhya* (Intellect promoting)	*Celastrus paniculatus* (*Jyotismat*)
• *Madakārī* (Narcotic)	*Hydrocotyle asiatica* (*Mundukaparni*)
	+ *Papaver somniferum* (*Opium*)
• *Sañjna-sthapana* (Resuscitative)	*Acorus calamus* (*Vaca*)
• *Nidrā-jnana* (Hypnotic)	*Rauwolfia serpentina* (*Sarpagandha*)
• *Vadana Sthapana* (Analgesic)	*Commiphora mukul* (*Guggulu*)

PLANT AND ANIMAL PRODUCTS FOR SPECIFIC CURES

- **Plants with anti-fertility activity**
 Abrus precatorius (*guñjā*)
 Butea monosperma (*pālāśa*)
 Curcuma longa (*haridrā*)
- **Plants with uterine activity**
 Asparagus racemosus
 Area catechu (*puga*)
- **Plants with anti-inflammatory acitivity**
 Allium sativum (*laśuna*)
 Berberis arista (*dāru-haridrā*)
- **Plants with cardiovascular activity**
 Acorus calamus (*vacā*)
 Digitalis lanata (*hṛtapatri*)

- **Plants with anti-hypertension activity**
 Achyranthes aspera (apāmārga)
 Bacopa monniera (brahmī)
- **Plants with hypoglycaemic (anti-diabetic) activity**
 Pterocarpus marsupium Roxb. *(asana)*
 Momordica charantia (susavi)
- **Plants with anti-cancer activity**
 Abrus precatorius (guñjā)
 Albizzia lebbeck (śirīśa)
- **Plants with hypolipaemic activity**
 Commiphora mukul (guggulu)
 Curcuma longa (haridrā)
- **Plants with anti-bacterial activity**
 Acorus calamus
 Achyranthes aspera (apāmārga)
 Alpina galanga (sugandha vacā)
- **Plants with anti-fungal activity**
 Asteracantha longifolia (kakilākśya)
 Cassia Fistula (suvarṇaka)
- **Plants with anti-viral activity**
 Amura rohitaka (harinhara)
 Azadirachta indica (nimba)
- **Plants with anti-protozoal activity**
 Berberis aristata (dāru-haridrā)
 Centella asiatica (muṇḍukaparnī)
- **Plants with anthelmintic activity**
 Butea frondosa (palāśa)
 Embelia ribes (viḍaṅga)
- **Plants with insecticidal activity**
 Acorus calamus (vacā)
 Euphorbia neriifolia (snuhī)
- **Plants with diuretic and anti-urolithiatic activity**
 Boerhhavia diffusa (punarnavā)
 Tribulus terrestris (gokśura)
- **Plants with anti-asthmatic and anti-histaminic activity**
 Adhatoda vasica (vāsā)
 Curcuma longa (haridrā)

- **Plants with respiratory activity**
 Salanum xanthocarpum (kaṇṭakaṛī)
 Adhatoda vasica (vāsā)
- **Plants with anti-peptic ulcer activity**
 Terminalia chebula (harītakī)
 Phyllanthus emblica (āmalakī)
- **Plants with astringent activity**
 Ferula faetida (hiṅgu)
 Allium sativum (laśuna)
- ***Dravyas* for oleation**
 Animals fats
 Vegetables oils
- **Plants with antipyretic action**
 Azadirachata indica (nimba)
- **Plants with anti-leprotic action**
 Acacia catechu (khadira)
 Hydnocarpus wightiana (tuvaraka)
- **Anti-hiccup action**
 Feather of peacock (mayurapiccha)

14

SROTAS

The *Caraka Samhitā* has explained that the body is made up of *srotas*, i.e. macro and micro channels meant for specific purposes. The concept is based on the fact that these are specific *srotas* for all the *bhavas* (entities, organs, tissues, *doṣās*) that can be conceived in the body. It means that the whole body is nothing but an aggregation of *srotas*. These are of several types. These *srotas* are meant to provide structural as well as functional support by circulating basic elements and removing unwanted waste products from the body. All the channels, right from the big gastro-intestinal tract to the fine microscopic capillaries, have their specific functions.

For the purpose of explaining the concept of *srotas*, the 13 important *srotas* had been enumerated, as follows:

- **Prāṇavaha srotas:** Channels carrying air (*prāṇa vayu*) from outside to the bloodstream.
- **Udakavaha srotas:** Channels carrying water. These include those carrying serum.
- **Annavaha srotas:** Channels carrying food items (*anna*).
- **Rasavaha srotas:** Channels carrying products of metabolic processes.

- *Raktavaha srotas:* Channels carrying the haemoglobin fraction of blood.
- *Maṁsavaha srotas:* Channels meant for providing nutrients to muscles.
- *Medovaha srotas:* Channels carrying nutrients to fat tissues.
- *Asathivaha srotas:* Channels carrying nutrients to bone tissues.
- *Majjāvaha srotas:* Channels carrying bone marrow.
- *Śukravaha srotas* and *ārtavavaha:* Channels providing nutrients to sperm (*sukra*) or ovum (*rajas*).
- *Mutravaha srotas:* Channels meant for urine (*mutra*).
- *Purīṣavaha srtota:* Channels meant for faeces (*purisa*).
- *Svedavaha srotas:* Channels meant for sweat (*sweda*)

To keep these channels working smoothly for carrying their specific nutrients or substances, there are many prescriptions and behavioural activities given in Āyurvedic texts. These include taking food on time, passing of excreta regularly, attending to natural urges of the body and physical exercises.

SYNONYMS

Srotas are known by the following names:

- *Srotas* (channels)
- *Sirā* (vein)
- *Dhamanī* (artery)
- *Rasāyanī* (lympathic channels)
- *Nāḍi* (duct)
- *Panthā* (passage)
- *Mārga* (track)
- *Śarirachidra* (space inside the body)
- *Saṁvṛtāsaṁvrta* (duct closed at one end and open at the other)
- *Sthāna* (residence)
- *Āśaya* (abode)

SITES OF ORIGIN

Proper functioning of *srotas* depends upon their healthy condition. Vitiation of these channels leads to the vitiation of tissue elements connected to them. The vitiation of channels and *dhātus* leads to the vitiation of other *dhātus* and channels. The three *doṣās*, when vitiated, cause vitiation of the channels and *doṣās* too.

Some details are given below to assess the sites of origin of *srotas*, and symptoms caused by their vitiation.

Heart and *mahāsrota* (central alimentary tract) are the sites of origin of the channels carrying *prāṇa vāyu*. This affects respiration and is associated with unhealthy beats and pain.

Tālu (palate) and *kloma* (pancreas) are the sites of origin (controlling organs) of the channels carrying watery elements. When these are affected, it causes excessive thirst.

Stomach is the origin of the channels carrying food and its derivatives. Vitiations of these channels lead to anorexia, indigestion and vomiting.

The urine channels are the bladder and the kidneys. Examine urine as well as urination.

For *malavaha srotas*, the sites are colon and rectum. Either very little faeces or excessive faeces with sound and pain result in case of vitiation of *srotas*.

Sweat channels originate from adipose tissue and the hair follicles. Vitiation causes very little perspiration, excessive perspiration, roughness, over-secretion of oil, and general burning sensation.

Similarly, others *srotas* are to be examined for proper diagnosis.

TREATMENT

For the treatment of the vitiation of *prāṇa, udaka* and *anna vaha srotas*, the treatment of respiratory, thirst and digestive systems respectively are done. Vitiation of *rasavaha srotas* can be corrected by different types of fasting. For vitiated *raktavaha*

channels, blood-letting may be done. For vitiated *mamsavaha srotas*, treatment can be through surgery, alkalis and cauterisation. For vitiated *medo-vaha srotas*, emaciation therapies may be helpful. For vitiated *asthivada srotas*, five types of purification, and enema of mild *ghee* boiled with butter is useful. Vitiated *majjāvaha srotas* and *śukravaha srotas* can be treated with a diet regime of sweet as well as bitter substances. There should be regularisation of sexual intercourse, exercise and timely elimination of *malas*. For the vitiation of *mūtravaha srotas*, the general treatment of urinary system is recommended. For the vitiation of *malavaha srotas*, the treatment of constipation or diarrhoea is recommended.

In Āyurvedic pathogenesis, *srotas* play a vital role. Blockage of one or more than one channels may lead to waste materials or *malas* finding their way into the gastro-intestinal tract. This may lead to accumulation of such excretory products, i.e. *srotorodha*, which is followed by *srotasduṣṭi*.

15

INTERNAL MEDICINE AND TREATMENT

Śāstram jyotiḥ prakāśārtham darśanam
buddhirātmanaḥ
Tābhyām bhiṣaksuyuktābhyām cikitsannāparādhyati
—*Caraka Saṁhitā, sūtra* 9; 23

This couplet is very significant and quite popular among medical teaching institutes. The literal meanings emphasise the two authorities, i.e. (1) *Śāstras* and (2) *Darśanam*.

Śāstram (textual writing related to science and technology): There are numerous *Śāstras* related to Āyurvedic treatment directly and indirectly. Judicious reading of these textual writings removes doubts and creates proper understanding. *Caraka Saṁhitā* has recommended that the physician should read, understand and adopt relevant and useful portions of other textual books. In the present context, these may be of modern medicine, i.e. Allopathy. The physician should read authoritative textbooks on anatomy, physiology, pharmacology, therapeutics, pharmaceutics, personal and social hygiene, surgery, dental surgery, ophthalmology, gynaecology, obstetrics and all related subjects with modern advances.

Darśana (visionary explanation of various complex and abstract issues or subjects): Different scientific, philosophical, metaphysical, physical, chemical, bio-chemical thoughts are enshrined in the form of *darśana*. These are of many kinds because of the variety of subjects and explanations thereon. There are two major groups — the theories of those believing in the Ultimate Reality or the creative power or God are known as *āstika darśana*; and that of those not having faith on the *Vedas* or Ultimate Reality are known as *nāstika darśana*. Materialism, reductionism, Buddhism and Jainism are considered to be *nāstika darśana*. The *darśana* of Cāravākas is also considered as *nāstika Darśana*.

The inner world is perceived through *darśana*, which cultivates spiritual intellect. *Darśanas* are meant to enlighten the individual and teach good manners, civility, etiquette as well as humility. All kinds of knowledge is based on these *darśanas*. For example, *sānkhya darśana* explains the process of creation of the universe, man, etc. *Darśanas* are meant to educate and mould our soul.

Cakra Datta, while commenting on the couplet under discussion, was of the view that *darśana* generates spiritual intellect, i.e. *buddhiātman*. Along with *sahaja buddhi* or natural intellect and academic intellect, there may also be a need of *vinayikic* intellect, i.e. humble or courteous intellect, which is based on the teachings of Lord Buddha.

The last word of the couplet *cikitsannāparādhyati*, i.e. treatment done without proper learning from textbooks and *darśana*, is a grave crime. It appears that the necessity for codes of conduct during treatment was stressed upon. Such a practitioner was watched and punished in case of violation of the established and legal practice. The vigilance department was active and there was provision to take permission from the king before practising work as a physician. Thus, proper registration was needed to practise in public. The necessity of having a professional qualification from an authorised and well-tested teacher was an essential requirement for registration by the State. The State agency was free to decide

the ability of disciples who got blessings from their teacher after proper teaching and training. Disciples had to satisfy the teacher by offering gifts to him as a token of love, respect and gratitude. The teacher decided on the nature of the gift.

INTERNAL MEDICINE

Internal medicine is known as *kāya cikitsā*. In order to understand the term, it is essential to clarify the term *kāya*. *Kāya, deha* and *śarīra* are three interrelated terms. In common parlance, these terms cover the 'body'.

Deha means to grow or to develop, viz. anabolic process of the body.

Śarīra means to be rendered into pieces so it is ketabolic processes of the body.

Kāya means 'to collect judiciously'. *Kāya cikitsā* is treatment used for treating metabolic diseases. Food is broken up, absorbed and assimilated by the *agnis*. When the body is in perfect health, then these *agnis* work perfectly. When there is disturbance in the equilibrium, the *agnis* or enzymes cease to function normally. This impairment in the functioning of metabolic processes has been studied as per the states of metabolism or *agnis*.

There are four stages in metabolism: (1) *visāmāni*, (2) *tikśnāgni*, (3) *mandāgni*, and (4) *samāgni*.

1. *Viṣamāgni* (irregular metabolism): As the name indicates, this stage of metabolic process is very irregular in nature due to the influence of the nervous system. It is observed that the digestive system works properly for some time, after which there is disturbance and it either becomes weak or very strong. This type of functioning causes pain in abdomen, constipation, diarrhoea and dysentery, etc.

2. *Tīvarāgni or tikśnāgni* (excessive metabolism): The metabolic process is very quick due to excessive *jathara āgni*. This is due to predominance of *pitta doṣā*. An excited digestive system

causes a parched throat, parched lips, parched palate and a burning sensation in the abdomen. Heavy meals are digested within a very short time. Due to this, the subject feels hungry very fast. This is also termed *bhasmakātyagni* or *bhasmaka roga*.

3. **Mandāgni** (weak metabolism): The metabolic process is very weak due to the influence of *kapha doṣā* on the digestive system. The name *manda* indicates weakness or slow functioning. Even small quantities and easily digestible food may not be digested at all. Heaviness of abdomen and head, cough, general weakness follow.

4. **Samāgni** (normal metabolism): Diet in proper quantity gets digested in time. A balanced digestive system is due to equilibrium of the *vāta, pitta,* and *kapha.*

Having explained *kāya,* let us look at the word *cikitsā.* It is derived from the root *kit rogā panayane,* i.e. to undertake measures for removing causative factors and the line of action against the causative factors. Any action that restores equilibrium of supportive elements is called *cikitsā.*

Kāya cikitsā, thus, is treatment of the whole body. This whole body is the outcome of nutrition (*āhāra*). Diseases are caused by impairment of nutrition and the metabolic process. With malfunctioning of the metabolic process, the nutrition required for growth and energy is not available, and malnutrition or impairment of nutrition in turn causes diseases.

The entire drama is thus enacted by two players, i.e. nutrition and *agni* or metabolism. Faulty nutrition causes misery, pain and ailments. Useful and wholesome nutrition gives pleasure, happiness and health. Āyurveda has given significant importance to *agni.* Physico-chemical changes may occur due to generation of heat (exothermic action) or absorption of heat (endothermic action). Anabolic and katabolic proceses are continuously going on. New cells are born and old ones give place to new. The *agnis* are named as per the site of function. Cells are conceived as *paramāṇu* in

Āyurvedic parlance. These are biological micro-units which are smaller than atoms.

SELECTION OF THERAPEUTICS

The following factors should be considered while prescribing treatment to patients for the cure of diseases.

- Variations relating to doses
- Variations relating to drug
- Variations relating to place
- Variations relating to time
- Variations relating to strength
- Variations in body, figure, etc.
- Variations in respect of diet
- Variations relating to wholesomeness
- Variations relating to mind
- Variations relating to constitution
- Variations relating to *agni*, i.e. the metabolic process

SYNONYMS

Bhesaja or treatment is known by various other names. These are:

- *Cikitsitām* (treatment)
- *Vyādhihara* (destroying disease or removing illness)
- *Pathyam* (conducive to health, compatible regimens)
- *Sādhana* (instruments that mitigate causes and effects of disease)
- *Auṣadham* (drugs that consume the disease)
- *Prāyacittam* (penance or expiation)
- *Prasāmanam* (pacification or mitigation)
- *Prakṛti sthāpana* (establishment of nature)
- *Hitam* (suitable for health and its nourishment)

Bheṣaja stands for victory over illness or disease. The synonyms given indicate two basic functions of treatment — (a) promotion and preservation of health, and (b) elimination

of the disease in ailing and afflicted individuals, family, community and society.

The aspect of promotion and preservation of health includes preventive and prophylactic strengthening of the immune system by the observance of hygiene (*swasthavṛtta*). Caraka had laid down injunctions for epidemics (*janapado-dhwamsaniya*) and adaptation of measures described under *rasāyana* (immunity) and *vājīkaraṇa* (strengthening of sexual hormones).

The second method for elimination of diseases is the curative treatment that comprises:

- *Śamana* (palliative and sedative measures)
- *Āhāra* (food)
- *Ācāra* (mental behaviour and healthy living)

Purification, i.e. radical removal of causations of psychosomatic diseases is of three types:

- *Antahparimārjana* (internal purification)
- *Bahiyaparimārjana* (external purification)
- *Śastra pranidhāna* (surgical measures)

Internal purification is achieved by oiling, sweating, vomiting, purgation, etc. External purification is achieved by external oiling, sweating, external massage, steam massage, hydrotherapy, acupressure, etc.

MENTAL ILLNESS

Mental diseases are treated by *satwāvajaya* (psychiatry). In order to avoid unwholesome food and their actions, the adaptation of certain therapeutic measures is recommended, for example, *jñāna* (counselling or imparting knowledge), *vigñāna* (scientific and tecnologic application), courage, memory (revival of normal functions of consciousness) and *sāmādhi* (concentration, yogic exercises and postures).

Āyurveda envisages another method called *daivavypāśraya* or spiritual therapy. There are various ways to treat mental cases. These are:

- *Mantrās* (incantations for achieving desired goals)
- *Auṣadhi* (drugs)
- *Mani* (precious gems or stones to protect from ill effects of heavenly bodies)
- *Maṅgala* (propitiary rites, rituals and oblations)
- Sacrifices or offerings to gods and goddesses
- *Homa* (specific sacrifices)
- *Niyama* (vows)
- *Prāyścitta* (ceremonial repentance)
- *Upavāsa* (fasts)
- *Swastyāna* (prostrations)
- *Praṇipāta-gamana* (pilgrimages)

EXAMINATION OF PATIENTS

Diagnosis of diseases is very elaborate. There are eight types of examinations for identifying the disease. The examination of each item is quite different to what modern medicine has explained.

1. Pulse examination

Pulse examination, as per Āyurvedic principles, is carried out by the physician in the early morning when the patient has not eaten anything. The patient should not be examined immediately after exercise and oil massage, because in these or other such conditions, the pulse becomes erratic and does not give a correct reading. Any immediate exciting cause, fear and natural calls also are not suitable for pulse reading. Different diseases produce different types of pulse readings. Expertness lies in regular practice and observations.

Radial artery of the right hand in case of male and life hand in case of female is examined. Stretching of arm and fixing the hand in proper and relaxed condition are done. Fingers and thumb should be in a stretched position. Physician's right hand is applied; three fingers are used for examination. The thumb is to be placed below the wrist. Gentle and uniform pressure is applied through the tips till

pulsation of the artery is felt properly. There should be slight pressure and then relaxation. This technique is to be repeated till the pulsation is recorded more on one finger than on the other two fingers. Index finger is meant for the domination of *vāta* or *vāyu*. The middle finger shows the domination of *pitta* and the ring finger for *kapha*. Aggravation of one *doṣā* or two or three *doṣās* has to be assessed as per the pulsation of the radial artery, called *nāḍī*. The examination is called *nāḍī parikṣā*.

Movement of the pulse is the second point to be assessed. The movement is compared with the natural movement of animals. When the movement is like a snake or a leech, it indicates the dominance of *vāyu*. Movement of pulse similar to a crow, sparrow or frog indicates the dominance of *pitta*. The dominance of *kapha* is indicated by the movement of a swan, peacock or cock. Dominance of *pitta* and *kapha* is shown by a movement similar to that of a monkey and a swan. When all three *doṣās* dominate, it is indicated by a movement like that of a woodpecker.

2. Urine examination

Examination of urine is needed in various diseases in general and urinary system diseases in particular. Collection of the sample is done in a glass container. The urine of the last quarter of the night, leaving the urine that comes out in the first instance, should be collected for examination after sunrise.

Urine that is pale yellow in colour indicates dominance of *vāyu*. White in colour and lot of foam in the urine indicates the dominance of *kapha*. A bright yellow or red colour of the urine shows the dominance of *pitta doṣā*. Indigestion causes the urine to look like a rice wash. There are various types of appearances due to various types of diseases.

One or two drops of oil are dropped in the urine kept in a wide-mouthed glass. If the oil spreads immediately, then the patient is curable. If the oil spreads slowly, then the patient is difficult to cure. If the oil drops go down the urine, the

patient is sure to die. An elaborate description about diagnostic and prognostic values of urine examination has been provided in the classical texts.

3. Stool examination

Due to dominance of *vāta*, the stool becomes hard and dry. Yellow colour indicates the dominance of *pitta*; white indicates the dominance of *kapha*.

Sinking of the stool indicates indigestion and the presence of *āma*. Floating is a sign of a good metabolic process, which is functioning properly. The colour, smell, consistency, etc. indicate different conditions of the disease.

4. Tongue

If *vāyu* is vitiated and aggravated, then the tongue is rough and has cracks. Colour of tongue is dark. If *pitta* is aggravated, then the tongue is red or blue in colour and irritated. If *kapha* is aggravated, then the tongue is white, slimy and heavy. If three *doṣās* are aggravated, then the tongue appears black in colour and has thorny eruptions over it.

5. Voice

The voice is affected due to aggravation of *doṣās*. In case of *vāta*, the voice is dry and hoarse. In case of *kapha*, the voice is heavy. If voice is sharp and clear, then *pitta doṣā* is involved.

6. Touch (skin)

Pitta causes burning sensation and the skin becomes too hot. In case of *vāta*, the skin is cold and the skin is moist and wet if *kapha* dominates.

7. Eyes

Eyes are the index to the inner condition of the body and the mind. *Vāyu* produces dry and smoky eyes if aggravated. Burning sensation is also experienced. In case of aggravated *pitta* there is redness and aversion to light. In case of predominance of *kapha*, eyes are usually moist and have

profuse lachrymation. Condition of iris and its colour also help in diagnosis of the disease.

8. Physical forms and features

Dry and cracked skin and hair are observed in case of aggravated *vāta*. A dislike for cold food, impatience, and loss of memory, intellect and endeavour are other indicators. Patients suffering from *pitta* feel excess thirst and hunger. Skin may be yellow in colour and warm to touch. Colour of palm of the hand, the soles of the feet and face is coppery. Nature is aggressive and egoistic. There is less hair, which is reddish in colour. If *kapha* is aggravated, then the patient has compact joints, bones and muscles. Signs and symptoms of *kapha* are quite noticeable.

Examination of disease

Examination of disease is based upon the following aspects:
* *Doṣās* - involved
* *Dhātus* - affected
* *Malas* - vitiated
* *Srotas* - blocked and vitiated
* *Agni* - examination of metabolic processes
* Examination of *nidana* - causative factors
* *Pūrvarūpa* - early stage of disease
* *Rūpa* - appearance of signs and symptoms
* *Upaśaya* - exploratory therapies
* *Samprāpti* - development of actual disease, i.e. pathogenesis
* *Upadrava* - complications

The success of treatment is achieved through four factors. These are given below:

* Physician
* Drug
* Patient
* Nurse

These are four pillars of treatment. For that, the best qualities are needed to achieve success in curing patients. Characteristics of each component have not been provided here. Āyurveda gives details thereon.

16

PAÑCAKARMA

Five actions or operations form the *śodana* treatment, which is now becoming popular in urban Āyurvedic institutions. Actually, nature cure and physiotherapy have derived a lot from this aspect of Āyurvedic medicine. This treatment was very popular in the Āyurvedic milieu of early years. Due to various reasons, it was not practised systematically and scientifically. Recent observations indicate that this branch of Āyurvedic treatment plays a very important role in the treatment of nervous and chronic diseases, which are not cured by modern Allopathic system of medicine or by palliative and symptomatic treatment.

SALIENT FEATURES OF *PAÑCAKARMA*

Pañcakarma is systematic cleaning of the body without damaging the tissues. It improves the functioning of all organs and systems of the body. Metabolic obstructions are removed and the anabolic process is strengthened. The katabolic process at tissue level also becomes effective and efficient to increase the immune system. The *pañcakarmas* activate the hormone-producing glands. *Rasāyana,* i.e. strength and anti-aging treatment works successfully with its help.

Pañcakarma assures permanent cure for diseases. It improves health-promoting, disease-preventing mechanisms. It facilitates permanent cure for chronic illnesses. It enhances the functional processes of organs or systems responsible for the excretion process. Excretory products such as urine, stool and sweat remove unwanted and disease-producing substances or *malas*. It prepares sufficient ground for quick action of preparations given to patients.

There are practically no side effects in this treatment. It can be understood and practised by individuals with some training and experience. It may be possible to cure surgical cases at an early stage. With the removal of unwanted matter from the body, the 13 types of inner fires become very efficient. These 13 inner fires are: digestive system called *jatharāgni*, five *mahābhūtasāgni*, seven *dhatuwāgni*. A *panchakarma* department can be organised on modern lines with modern sophisticated equipment. It further demonstrates the potentiality of the therapeutic aspect of Āyurveda.

GENERAL TECHNIQUES OF *PAÑCAKARMA*

It is not within the scope of this book to give details. However, the names of the few techniques are given:

- Oblation or lubrication—internal as well external.
- Sweating or sedation.
- Vomiting or emetics.
- Purgative, including laxative drugs.
- Enema.
- Nasal medication.
- Blood-letting.
- Medicated smoking.
- *Dharā* (study of the flow of lubricants on the body, specially the forehead of the patient).
- *Navarai kizhi*(massage combined with the application of extracts of glutinous rice or broken wheat and milk).
- *Pichu* or *pizhichal* (sponging the body with cotton sponges dipped in medicated oils).

17

SURGERY

Surgery is one of the main branches of Āyurveda. *Suśruta Saṁhitā* is an excellent treatise on ancient surgery. It owes its origin to the beginning of the universe. It is considered that surgery in Āyurveda, known as *śalya*, was the first to come into existence. Lord Dhanwantri, who appeared with the *amṛta kalaśa* (pot of nectar) and knowledge of Āyurveda when *sura* (noble gods) and *asura* (devils) were churning the ocean for rare valuable articles, is said to have established the tradition of surgery, which is known as *Dhanwantariya sampradāya*.

Śalya tantra consists of knowledge of anatomy and surgery. Lord Dhanwantri specialised in it and his mastery over the subject made him immortal. A large galaxy of brilliant students popularised his techniques and methodologies of performing various kinds of surgical operations. He was the first surgeon of the world and the greatest healer of all kinds of ailments of human beings. Subsequently, Suśruta and Charaka produced the most comprehensive work of Āyurvedic surgery.

The term *śalya* stands for every kind of foreign body — dried fibre, piece of wood, stone, dust, iron, bone, hair, nail, pus, drainage, vitiated wound, inner foreign body, foreign

body in foetus, etc. For operating, there are many types of instruments, alkaline reagents and chemicals as well as equipment described in *Suśruta Samhitā*.

According to Lord Dhanwantri, surgery is very important and it is superior to other parts of Āyurveda. It could replace the head that had been cut in the battle. It is known for its quick action when brought into play with the help of equipment, instruments, chemicals, etc. Surgery is an eternal branch of Āyurveda. It bestows fame, name and material gains as well as peace in heaven after death. Lord Dhanwantri informed his disciples that he was initially the legendary Dhanwantri who cured gods in their abodes from old age and disease. He was born again for the purpose of teaching surgery on the earth. Surgical treatment is, however, an option kept for the secondary stages of any disease. *Suśruta Samhitā* advocates surgical treatment only if drugs, diet and other measures fail to elicit positive responses.

TYPES OF DISEASES

According to the surgical school, there are four types of diseases — *āgantuka* (due to external causes), *śāririka* (internal causes), *mānasika* (due to psychic disturbances) and *svabhāvika* (due to natural consequences). Diseases above the neck were categorised under *śālākya*. Diseases of eyes, nose, throat, skull, face and brain are covered under it:

1. *Āgantuka rogas:* These are due to foreign bodies affecting an individual's structural and functional constitutions.

2. *Śāririka rogas:* These are due to foods and behavioural defects.

3. *Māmsika rogas:* These are caused by anger, fear, depression, worry, excessive happiness, pain, jealousy, poverty, over-indulgence, greediness, avarice and death. Differentiating on the basis of desire or malice is the cause of deficiency and mental diseases.

4. *Svabhāvika rogas:* These are due to hunger, thirst, old age, death and sleep, etc.

All these four types of diseases are psychosomatic in nature.

REMEDIAL MEASURES

The surgical school recognises that diseases are treated by four types of remedial measures:

1. *Saṁśodhana* (purification): External purification is done by instruments, *kśara* (chemicals) and *agni* (cauterisation), etc., while internal purification is conducted by giving emetic drugs, purgation and different types of enema meant for removing vitiated matter, blood oozing by surgical operation, etc.

2. *Saṁśamana* (palliative treatment): *Saṁśamana* is an internal medicine in which digestives, sedatives, nutrients and drugs are given to cure diseases. Externally, paste or *lepa*, massage, gargle, oiling are advisable.

3. *Āhāra* (food, dietitics): These are of three types, such as (a) subsiding vitiated elements, (b) subsiding diseases, and (c) health-promoting diets.

4. *Vihāra* (behaviouralism): It covers various types of bodily, vocal and mental actions, self-study, thinking, etc.

Minerals, gold, silver, earth, diamond, gems and precious stones, and arsenic ore are grouped under *pārthiva* drugs, i.e. drugs having 'earth' as the predominant primordial entity. Another type of drug is called *kālakṛta auṣadha* (drugs processed by time). For example, places having excessive air or no air, sunshine, shadow, moonlight, darkness, cold, heat, rain, day and night, time periods like a month, half-year (*ayana*), year, climatic condtions, etc., are aspects of time that affect the drug.

Somatic diseases are treated like any other disease of the body and psychic diseases caused by external elements are treated by sound (*śabda*) or counselling, touch (*sparśa*), vision (*rūpa*), taste (*rasa*) and smell or aroma (*gandha*). Sound covers music therapy, counselling, tranquillising words or tunes.

CHAPTERS OF *SUŚRUTA SAṀHITĀ*

Sutrasthāna

First : It is named *Vedotpattimadhyāmam* — *Suśruta Saṁhitā* has expounded that Āyurveda is derived from one of the four *Vedas* named *Atharvaveda*. So it is a part constituted by Svayambhu, i.e. Creator who is Himself creator of His own entity.

Second: *Śisyopananīyamadhyāyam* —The second chapter deals with imparting Āyurvedic education in general and surgical education and training in particular.

Third: *Adhyayanasampradānīyamadhyāyam* — It deals with studies of Āyurveda in general and *Suśruta Saṁhitā* in particular.

Fourth: This chapter is called *Prabhāṣanīyamadhyāyam*, i.e. to study Āyurveda with meanings and applications. It is advised here that students should consult related treatises because it is very difficult to include all branches of learning in one treatise. Further, one should not restrict one's learning to one treatise.

Practical training should be given more importance than theoretical discourse. If this is not adhered to, then one is considered a thief (*taskara*). It is stressed that one should study surgical treatises of *aupadhaneya, aurabhra, pauṣkala, karvirya, gopura rakṣita*, etc. It means that the classical approach to study and training of surgery were based on thorough practical training and comprehensive study to enlarge the horizon of knowledge and expertise.

Fifth: This chapter is named *Agropaharaṇīyamadhyāyam*, and is related to surgical operations. Pre-operative, operative and post-operative aspects are covered. Eight types of operations and various equipments and instruments have been enumerated.

Sixth: This chapter is named *Ṛtucaryadhyāyam*, i.e. behaviour during different climates. General treatment for the perverted seasons is based on rituals for gods called *daivyapāśraya* drugs or treatment. These measures include vacating the old place, conducting peace, ushering rites, recitation of *mantras* described in *Vedas*, use of auspicious stones, offering sacrifice at religious fire, ceremony to please gods by sacrificing animals or vegetables, paying one's respects, observing silence, charity, becoming part of a spiritual cult, and serving gods and noble personalities.

Seventh: This chapter is named *Yantra Vidhimadhyāyam*. There are numerous equipments and instruments of different shapes for performing different functions. The hand is said to be the first important instrument.

Eighth: This chapter deals with the cutting instruments or knives. It is named *Śastrāvacāraṇīyadhayāyam*. These may be enumerated as given below:

- *Mandalāgra yantra* (circular knife or round-headed knife)
- *Karapatra yantra* (saw)
- *Vṛddhi patra yantra* (scalpel having abscess knife)
- *Nabhaśastra* (nail pairs)
- *Mudrika* (finger knife)
- *Utpala Patra* (lancel)
- *Ardhadhārā* (single-edged knife)
- *Sūci* (needle)
- *Kuśa Patra* (bistoury)
- *Kuthārikā* (axe-shaped knife)
- *Sūci* (curved bistoury)
- *Vrihimukha* (troche)
- *Ārā* (owl-like knife)
- *Vetasa Patra* (narrow-bladed knife)
- *Badiśa* (hooks)
- *Dantaśanka* (toothpick)

Material to be used, defects, utility and effectiveness have been provided.

Ninth: This chapter stresses the need of practice, continuous education and training in surgical operations. It is named as *Yogyāsūtriyadhyāman*.

Tenth: This chapter is related to the outlook of surgeons. It gives directions in respect of relationship with patients in general and women in particular. It is named as *Viśikhānpraveśanīya- madhyāyam*.

Eleventh: This chapter describes the preparation of alkalis. These are of two types: (1) *pratisārana kśara* (external applicants), (2) *pānīya kśāra* (internal use). Each aspect of *kśara* is given. It is names as *Kṣārapākavidhimadhyāyam*.

Twelfth: This chapter is related to cauterisation (*agni kārma*). Material used for *agni kārma* is described for different diseases. Summer and autumn seasons have not been recommended for *agni kārma*. Excessive or wrong burning should be avoided. It is named as *Agnikarmavidhimadhyāyam*.

Thirteenth: This chapter is related to blood-letting and is recommended for almost everyone including kings, rich persons, old-aged, weak, coward, timid men, women, gentle and kind natured persons. When blood is vitiated with *vāta*, a specially designed horn is used. If it is vitiated with *pitta*, leaches are used. If blood is vitiated with *kapha*, a pot made of dried gourd is used. Horn of cow is useful for removing the vitiated blood with *vāta*. It is named as *Jalaukāvacāranīya-madhyāyam*.

Fourteenth: This chapter explains the importance of blood. For knowing the formation of blood, metabolic processes have been described. Vitiated blood has to be removed. This process is called *rakta mokṣana*, i.e. removing blood. This can

be done in two ways: (a) *prachāna* and (b) *siravyadhana*. *Prachāna* is similar to prophylactic vaccination in smallpox. The second process of *siravyadhana* is just like intravenous injection. It is named as *Śoṇitavarṇanīyamadhayāyam*.

Fifteenth: This chapter is related to *doṣā-dhātu-mala kṣaya vṛddhi vigñāna*, i.e. science of increase and decrease of vitiated elements, supportive elements and excretions like faeces. It is indicated that vitiated elements (*doṣā*), supportive elements (*dhātus*) and excretions (*malas*) are roots of the body, and behave just like the roots of plants that are responsible for the origin, growth and decay of trees. It is called as *Doṣadhātumalakṣaya-vṛddivigñānīyamadhyāyam*.

Sixteenth: This chapter deals with *karna vyadhabandhan vidhi*, i.e. method or ceremony of piercing the ears of children. This is done for two purposes: (a) security from evil eye, and (b) ornamentation. Under this chapter, surgical operations for various parts of the face, such as lip, nose, etc. are explained. It is named as *Karṇvyadhanavidhimadhyāyam*.

Seventeenth: This chapter is concerned with *Āmpakvesaṇīyadhyāyam*, i.e. assessment of various stages of inflammation. It is propounded that inflammation is the cause of various diseases. Six types of inflammation have been described. Diagnosis and treatment of both external and internal inflammation have been explained in detail.

Eighteenth: This chapter deals with *Vranālepanabandhavidhimadhyāyam*, i.e. external application of poultice, ointment, bandage, etc. In this chapter, the primary elements of surgery are propounded upon.

Nineteenth: This chapter is related to wounded persons and methods for providing services to them. It is known as *Vaṇitopāsanīyamadhyāyam*.

Twentieth: This chapter classifies useful and useless things, i.e. *Hitāhitiyamadhyāyam.* Diet and behaviour have been described.

Twenty-first: This chapter is named *Vraṇaprasnamādhyāyam.* The three *doṣās, vāta, pitta* and *kapha* are like three pillars of one house. In their natural state of functioning, these support the growing body. In their vitiated state, they harm the body. Due to this being a surgical treatise, a fourth basic element, blood, has also been included. It is explained subsequently that the four entities are essential to support the *deha* (growing body).

Twenty-second: This chapter deals with oozing of wounds called *Vraṇa-sravavigñāniyamadhyāyam*: Skin, muscles, veins, ligaments, bones, joints, *kostha* (vessels) and *marma* (vital parts of body) are sites of wounds. Details in respect of wounds have been provided, such as their nature, treatment and complications.

Twenty-third: This chapter deals with curable and incurable wounds, depending upon various conditions such as age, health and mental condition of the patient as well as nature of the wound. It is named *Kṛtyākṛtyavidhimadhyāyam.*

Twenty-fourth: This chapter is named as *Vyādhisamuddeśiya-madhyāyam,* i.e. related to diseases. There are two types of diseases. One type is to be operated upon, while the second type is to be treated while applying five types of purification. It is claimed that all types of surgical treaties had been incorporated in *Suśruta Saṃhitā.* This chapter contains the summary of all the braches of Āyurveda.

Twenty-fifth: This chapter deals with surgical operation. It is named *Aṣṭavidhaśatrakarma.* Details regarding eight types of surgical operations are given, while disease is enumerated against the type of surgical technique required thereon.

Twenty-sixth: This chapter is named *Prānaṣṭaśalyavigñāniya-madhyāyam*. Foreign bodies are named *śalyas*. These are of two types: (1) *śārīrika* (2) *āgantuka*. Details of *śalyas* are provided.

Twenty-seventh: This chapter indicates the position of a foreign body lying deep or just below the outer layer in the bone, etc. Various foreign bodies in various parts of body have been indicated for surgical operations. It is named as *Śalyāpana-yanīyamadhyāyam*.

Twenty-eighth: This chapter deals with *Viparītāviprītavraṇa-vigñāniyamadhyāyam*, i.e. bad omens observed by patient or relatives and even surgeon, described as *riṣṭa*. These signs and symptoms lead to a sure death of the patient. These may be based upon stimuli of sense organs, such as sound, touch, vision, taste and smell.

Twenty-ninth: This chapter deals with bad omens caused by specific constellations, mid-day, lunar day such as fouth date, presense of snake, sound of owl, cold and soft air. Country or region of surgeon, body and mental activities of the patient convey good and bad omens for predicting the results. It is named as *Vipritāviprītasvapnanidarśanīyamadhyāyam*.

Thirtieth–thirty-first: These chapters deal with bad omens and *chāya* or shadows. If black, red, blue, or yellow shadows appear suddenly, the patient is not going to survive. If there is loss of lustre, intellect, memory and grace along with other behavioural goodness, these omens are indicative of definite death. Thirtieth chapter is *Pañcendriyārthvipratipatti-madhyāyam*. Thirty-first chapter is called *Chāyāvipratipatti-madhyāyam*.

Thirty-second: This chapter also describes omens and is named as *Svabhāvavipratipattimadhyāyam*.

Thirty-third: This chapter is named *Avāraniya*. Diseases that are not curable are diagnosed by four factors: (1) *kāla* (time), (2) *svabhāva* (nature), (3) *riṣṭa* (bad omens), and (4) *upadrava* (complications). In this chapter, complications have been described and named as *Avāraṇīyamadhyāyam*.

Thirty-fourth: This chapter deals with appropriate steps to be taken to protect the king, ministers and other dignitaries from death caused by external danger, such as poisons. Physicians who are expert in *rasa śāstra* (chemistry) and psychiatry should protect the king from external danger and poison. Chapter is named as *Yuktasenīyamadhyāyam*.

Thirty-fifth: This chapter named as *Āturopakramaṇīya-madhyāyam*, deals with essential points to be examined by the physician. First of all, it should be ascertained whether the patient has got life to live or not. In case of hope, then he should be examined in respect of disease, season, digestive power, age-growing nature of patient, strength, psychic nature, adaptation, constitution, drug, region, etc. Each item is explained in detail.

Thirty-sixth: This chapter gives details of various kinds of soils and collection of herbs, minerals, etc. for treatment. It is named as *Bhumipravibhāgiyamadhyāyam*.

Thirty-seventh and thirty-eighth: These contain lists of various drugs grouped as per their combined properties. Thirty-seventh chapter is named as *Miśrakamadhyāyam*. Thirty-eighth chapter is named as *Dravyasaṅgrahaṇīyamadhyāyam*.

Thirty-ninth: This chapter deals with purification and palliative treatment. A large number of drugs of vegetable origin have been included under each category. It is named as *Saṁśodhanasaṁśamanīyamadhayāyam*.

Fortieth: This chapter deals with *dravya* (substance), *rāsa* (taste), *guṇa* (properties), and *vipāka* (metabolic potency) as a scientific discourse. It is named as *Dravyarasaguṇa-vīryavipākavigñāniyamadhyāyam.*

Forty-first: This chapter gives specific and particular details on *dravyas.* It is named as *Dravyaviśeṣavipākavigñāniyamadhyāyam.*

Forty-second: This chapter deals with specific substances from the taste point of view. It is named as *Rasaviśeṣavipāka-vigñāniyamadhyāyam.*

Forty-third: This chapter gives an account of emetic substances and named as *Vamandravyavikalpavigñāniyamadhyāyam.*

Forty-fourth: This chapter gives details on those drugs that are purgative in action and named as *Virecanadravyvikalpa-vigñāniyamadhyāyam.*

Forty-fifth: This chapter is related to problems of drinkable water, fats and oils. Besides, there are also *mādya varga* and *mutra varga,* i.e. alcoholic and urinary categories. It is named as *Dravadravyavidhimahimadhyāyam.*

Forty-sixth: This chapter named as *Annapānavidhimadhyāyam,* deals with *Annapānavidhimadhyāyam,* i.e. foods and other items. Some groups of grains and relevant eatable items are described along with their properties.

Nidānasthāna

The *Suśruta Saṁhitā* gives the description of *vātika,* i.e. nervous diseases. In surgery, the nervous system plays a vital role because it controls other vitiated entities. Pain is the main effect of vitiation of supportive tissues. So, diagnosis of nervous diseases was given importance. Subsequently, piles, stone in kidney or urinary bladder, fissure in anus, diabetes, abdominal diseases, diseases related to female reproductive organs,

abscess, skin diseases, inflammation, labour, fractures, dislocation, orthopaedics, dental and facial diseases, diseases of throat, vocal cord and other surgical diseases are explained.

Śārirasthāna

It is very pertinent to note that here Suśruta has used terms *sarva-bhūtanām, jagata* and *avyaktam* to emphasise three points. One is that creation which came from *avyaktam*, that which is not visible or born. Invisibility is cause of its effects. There are eight visible entities. *Jagata* means that which is created and has taken birth. *Sarvabhūtanām* refers to all living beings. They are referred to as *bhūta* because the period of time in which they had evolved has elapsed after their evolution. They were not termed as *prāṇi* or living beings because the authority wanted to convey the role of five *pañcamahābhūtas* and the process of evolution.

Suśruta stressed the theory of causation after emphasising on the process of evolution. So, *bhūta*, means evolved one; not devils or bad souls as known by the common man.

Śārirasthana gives details about conception, pregnancy, birth of child, development of organs systems, body, etc. like the parts of the baby. In other words, the chapter refers to genetics.

Complete development of each organ is explained. In the sixth chapter, the vital parts of the body are enumerated and explained. Suśrutā identified 700 micro-ducts that carry all the requisite substances, nutrients and other items needed by the designated parts of the body. Anatomical descriptions have been provided.

Cikitsāsthāna

Under *Cikitsāsthāna*, Suśrutā started with wounds and inflammation instead of fever like *Caraka Saṁhitā*. After giving general medical treatment, surgical operations are recommended. In case of an emergency, for example, when a wound is caused by a sharp weapon or knife, immediate surgical

measures have been explained. Fracture of bones as well as dislocation, nervous diseases, piles, stone in urinary system, fissure in anus, skin diseases, leprosy, diabetic carbuncles, abdominal diseases, abnormal pregnancy, external and internal abscess, cysts, tumour, cancer, elephantiasis, inflammation, etc. have been expounded upon. Preventive medicine, aphrodisiacs, rejuvenation and immunity promotion, *soma* (elixir), *anśumāna soma* (special elixir), treatment through oil such as massage and oral administration, steam bath or sweating, *pañcakarma*, etc. are also described.

Kalpasthāna

Fumigation and smoking of drugs have been explained under *Kalpasthāna*. Suśrutā had enumerated toxicology and its related subjects.

Uttaratantra

Diseases of eyes and surgical measures and operations have been described. This section is planned to include diseases of eyes, nose and throat, paediatrics, diseases caused by external agencies, 63 combinations of taste (*rasa*), hygiene, views and contradictions on the treatment principles, different diagnoses of vitiated elements and causes of diseases. Āyurvedic surgery is like an ocean where the head is a very important part of the body. Surgeons are most interested in the diseases of the head and their treatment. Ophthalmology is explained in a comprehensive manner.

Various surgical techniques are included with reference to diseases. Diseases of ear and nose had been explained to give an idea about the conditions that are expected to arise during actual practice. Similarly, diseases of the head in general and pain in particular are discussed.

It is to be mentioned that diseases of children caused by constellations, planets and other celestial bodies have to be studied scientifically as these had been described with authoritative references.

Suśrutā Saṁhitā describes diseases also covered under internal medicine. These include fever, diarrhoea, general disability, pulmonary consumption, tuberculosis, diseases of heart, vitiated blood by *pitta*, epileptic fits, alcoholism, thirst, hiccups, asthma, bronchitis, pulmonary diseases, parasitism, parasitological diseases, cholera, anorexia, diseases of urinary system, hysteria, epilepsy, and insanity.

There are extensive descriptions of all types of instruments and basic techniques used in surgery and which resemble modern instruments and basic techniques. *Suśrutā Saṁhitā* is such a supremacy of surgery that *Caraka Saṁhitā* had left out those diseases from its text that required any kind of surgical intervention.

Surgery, though an integral part of Āyurveda, has not been continued due to several reasons. Revival of surgery is needed, whether supplemented or not with modern advances.

18

AGADA TANTRA: TOXICOLOGY

gada tantra or toxicology as a subject has been described in detail by Lord Ātreya to his disciple named Agniveśa. It has been dealt with in *Caraka Samhitā, Cikitsāsthāna,* Chapter 23. Lord Ātreya expounded on the way by which *viṣa* (poison) appeared in the universe. When gods and demon churned the ocean for the sake of *amṛta* (nectar), *viṣa* came out of the ocean prior to nectar. He had a frightening and dreadful personality. He generated *viṣāda* (depression) among the people. The creator then allocated him two places of existence on earth: the animal kingdom and the plant kingdom.

In the animal kingdom, there are various animals that possess poisonous substances. For example, snake, rat, scorpion, and so on. In the plant kingdom, some plants are known to have poisonous effects. For example, *Calotropis gigantea (arka), Euphorbia nerufolia, (snuhī), Giloriosa superba (kalihari), Datura stramonium (dhatūrā) Strychnos nuxvomica (kucalā),* etc. Some minerals found in Nature are also poisonous such as mercury, lead, arsenic, etc. All these substances are used after purification and detoxication in Āyurveda.

Suśruta Saṁhitā, Kalpasthāna, Chapter 2, described the following dwellings of *viṣa* in the plant kingdom: roots, leaves, flowers, fruits, bark, latex, extracts, gums, resins, petals, rhizomes and tubers. *Caraka Saṁhitā* had described another kind of toxin called *gara viṣa*. This is formed by mixing two or more substances that are non-toxic in nature.

Agada tantra is a significant branch of Āyurveda that includes toxicology and jurisprudence. It enumerates the characteristics of toxic substances, the damage caused by them and the immediate remedial measures necessary to avoid damage by these substances.

Viṣa has eight impulses or thrusts for affecting the body. It has 10 properties. Accordingly, 24 remedial measures are prescribed as antidotes. The remedial measures are:

- *Mantra*
- *Ariṣṭabandha* (arresting fatal signs)
- *Utkartana* (incision)
- *Niśapīdana* (suppressing)
- *Cūṣana* (sucking)
- *Agni* (burning with fire)
- *Pariṣecana* (draining and washing)
- *Avaghana* (bathing)
- *Raktamokṣaṇa* (blood-letting)
- *Vamana* (vomiting)
- *Virecana* (enema or purgative action)
- *Upadhāna* (application of drug inside the head)
- *Hṛdāvaraṇa* (protection of the heart)
- *Añjana* (application of drug as collyrium)
- *Nasya* (snuffing medicine)
- *Dhūma* (fumigation)
- *Lepa* (application of paste)
- *Auṣadha* (specific antidote called *agada*)
- *Pradhamana* (quick injection)
- *Pratisārana* (counteraction by rubbing medicated powder)
- *Prativiśa* (antidote)
- *Saṅgnāsthānapana* (bringing into consciousness)
- *Mṛtasañjivanī* (a herb that brings back life)

These measures are to be used in a selective manner. Each measure is expounded with details.

It may not be out of context to mention that Āyurvedic treatment in general implies removal of toxins generated by metabolic processes in the body by five therapeutics, called *pañcakarmas*.

The *Agada tantra*, has been prevalent since ancient times. It is said that in early times, beautiful women were given poison in small doses over a period of time, which resulted in their lips and saliva becoming poisonous. She thus transferred this poison to the king's enemy while kissing them, leading to the death of unfriendly kings.

Knowledge should be acquired from all sources, including scholars of other systems and tribal people. The toxicology of the drug depends upon its systematic knowledge. If one does not know the details of the drug, then the drug may act as a poison. On the other hand, with knowledge, even a toxic drug such as *vatsanābha* (aconite), and arsenic become effective as medicines.

Registration of physicians, permission to practice medicine and surgery, employment for detection of poisons in foods and drinks of kings and other personalities were very much in practice. It is one of the essential subjects of Āyurvedic doctors, at present.

19

BHŪTA VIDYĀ: PSYCHIATRY

Āyurveda has eight parts and *bhūta vidyā* is one of them. This branch of Āyurveda believes in the existence of past souls which are continuously trying to achieve *rāśi puruṣatva* (individual existence in the visible world). These souls are believed to have no bodily structure but are composed of five primordial entities or the five evolved basic elements and *ātma*. There are some experts who claim to have contacted unsettled souls or subtle godly entities through their mental strength or yogic expertise. There is even a strong view that wicked, cruel and dishonest people, having double or split personalities, and severely mentally deranged individuals, are also like *bhūtas*. Micro-organisms causing various diseases are also considered *bhūtas*. So, *bhūta vidyā* (knowledge) relates to the dead, the mentally ill amongst the living, as well as harmful micro-organisms.

The science behind *bhūta vidyā* has somehow got lost in the past. At present, this technology has gone into the hands of charmers, wizards, occultists, witch-doctors, necromancers and diviners. It has been reduced to a simple matter of faith and belief. It is time to undertake research to get this technique into mainstream of medicine, so that it is recognised as a feasible mode of treatment for mental diseases.

The term *bhūta* in itself might convey the meaning 'ghost' and so on, but it has a more serious and scientific connotation. The role of shadow-soul, deformed and dangerous forces, still occupy the minds of scientists and parapsychologists all over the world.

Suśruta Saṁhitā, Sūtrasthāna, Chapters 1–4, have expounded that *bhūta vidyā* is a technique to remove the harmful effects of evil souls, demons, giants, heavenly musicians and dancers (*gandharva*), the attendant of the god of wealth (*kubera*) called *yakṣa*, dead relatives especially parents (*pitara*), devil (*piśaca*), snake (*nāga*), etc. It is the art of pacifying harmful entities and mental diseases. This art or technique is known as *satvāvajaya* and is very elaborate in nature. This technique is beneficial to both the evil souls, as well as the patient, who is suffering because of them. *Caraka Saṁhitā* has described *satvāvajaya* as a separate technique, exclusive of *daivavyapāśraya cikitsā*, and it has an independent existence of its own. However, the tradition of *satvāvajaya* did not find patronage as did *daivavyapāśraya* or *yuktivyapāśraya*. Mental diseases are also included under *daivavyapāśraya* and classified under *bhūta vidyā*.

Statistics indicate that mental diseases are on the rise every day. One view is that only the mental diseases caused by external factors (*āgantuja*) are included in *bhūta vidyā*. *Vāgbhata*, an authority of Āyurveda, had named it *graha cikitsā*, i.e. planetary influences causing mental diseases. It can also be described as the entry of an evil soul in a normal human being. Problems in children attributed to planetary changes are also included in *bhūta vidyā*. The *daivavyapāśraya* treatment, such as recitation of *mantras*, is said to give relief during these problems.

A second view is that micro-organisms cause various mental diseases. The third view has openly accepted the *bhūta vidyā* as the study of mental diseases for which the modern term is psychiatry. This school of thought considers *bhūta vidyā* to have a much larger scope than psychiatry, and as such, psychiatry is considered to be a part of *bhūta vidyā*, rather than vice versa.

Mental diseases are of two types: (1) diseases caused by *tamoguṇa* and (2) those caused by *rajaguṇa*. The different diseases caused by *tamoguṇa* are *unmāda, apasmāra, mada, murcchā,* and so on. Diseases caused by *rajaguṇa* include *bhūtunmada, būtagraha,* and so on. Hence, *bhūta vidyā* may be preceived from various angles described above in a limited way. However, this branch needs systematic research.

20

RASĀYANA: REJUVENATION

In old age, the predominance of *vāyu* and decrease of *kapha* and *pitta* cause many disorders. Body tissues do not get strength due to decrease in the anabolic processes. Enzyme systems (*agnis*) and sensory organs become weak. Weakness of memory, speech and knowledge is apparent. To delay the start of this aging process, Āyurveda has a specialised branch of study called *Rasāyana*.

Āyurveda considers *Rasāyana* as one of its eight branches. Hunger, thirst, aging and death are natural phenomena. So, there are specific lines of action prescribed in Āyurveda, which help to control these natural consequences. Changes in aging are inevitable and these are to be controlled in a systematic way. Āyurveda delays the process of decaying by improving the health of individuals.

There are many implications to the aging process. Āyurveda believes that a long life is not enough; it should also be a good healthy life. While stressing on a high quality of life at every stage, Āyurveda especially stresses on a high quality of life during the last stage. *Rasāyana* provides answers to the question of how to remain healthy throughout one's life span.

There are two major schools of thought regarding aging: (a) the genetic school, and (b) free radical school, which believe in the theory of mitochondria damage. The free radical school also believes that the aging process can be delayed with an integrated approach, i.e. herbal remedies, psychiatry, yogic exercises and meditation, as well as natural nutrition.

According to *rasāyana*, there is loss of different biological factors after every 10 years as given below:

Years	Factor Lost or Impaired at the End of the Period
00-10	*Balya* (infancy, childhood)
10-20	*Vṛddhi* (growth)
21-30	*Chavi, prabhā* (lustre)
31-40	*Medha* (intellect)
41-50	*Tvak* (skin health)
51-60	*Śukra* (sexual hormones)
61-70	*Dṛṣṭi* (vision)
71-80	*Śrotrendriya* (hearing), *vikrama* (strength)
81-90	*Manaḥ* (psyche), *buddhi* (wisdom)
91-100	*Gñānendriya* (sensory organs)
	Karmendriya (motor organs)

Systematic treatment of maladies in Āyurveda calls for purification of the body. This is achieved through five types of purification, which remove toxins accumulated in the body due to various factors. Therefore, the first step is to clean the body. This cleaning process should begin before the onset of each phase shown in the above table. To prevent aging in old age, precautions should be taken in the earlier stages.

Similarly, diet and behaviour followed by pregnant women should be such as to prevent psychosomatic disorders in the baby. As this is a continuous process, at each stage hereditary and congenital maladies can be prevented through *Rasāyana*.

Rasāyana includes both preventive and curative measures. It prevents disorders and cures diseases as well as promotes health. Even the drugs prescribed are of two types: one that strengthens the immune system of a healthy person and bestow general strength and promote life-giving power. The second is that which cures diseases in patients. Āyurveda also propounds a drugless treatment. This is further

classified as (a) *bāndhana* and (b) *sānubandhana*. Mild and temporary phase of the disease is called *bāndhana*, while the second type is known as *sānubandhana* and is used in cases where the disease is not immediatly curable.

BENEFITS OF *RASĀYANA*

Longevity, memory, intellect, positive health, youth, excellent complexion, strength of sensory and motor organs and lustre are gained through *Rasāyana*. The main aim of *Rasāyana* is to built a society of healthy people with youthful vigour of both body and mind.

ADMINISTRATION OF *RASĀYANA*

There are two ways to administer *Rasāyana*: (a) *kutīprāveśika* and (b) *vātātapika*. For the first type, elaborate arrangement is made for the construction of a special type of cottage where the individual is kept. The second form is a general one that rejuvenates the bodily and mental faculties.

TIME OF ADMINISTRATION

Administration of *Rasāyana* is time-bound and not effective in advanced stages of one's life. Two prerequisites are essential to start *Rasāyana*. These may be called pre-*Rasāyana* therapies. These are: (a) the individual should be physically prepared to go through the five steps of cleansing the waste products from the body, so that the body becomes ready to absorb elements that contribute to a healthy, beautiful and long life; (b) not only should the body be cleansed, the mind of the patient should also be prepared for the therapy. The individual should inculcate optimistic thinking, which will lead to his and the society's health.

PREPARATION FOR *RASĀYANA* THERAPY

The following behavour patterns have to be adopted for a successful accomplishment of the *Rasāyana* therapy.

- Speaking the truth and freeing the mind from anger.
- Abstaining from alcohol, sexual intercourse, and a luxurious lifestyle.
- Practising non-violence and not overstraining the mind and body.
- Peace and tranquillity at heart.
- Non-prejudiced and spiritual mind-set.
- Cleanliness.
- Respecting elders, seniors, parents, teachers, cows and god.
- Eating a balanced diet and practising self-control, trust and devotion.

COMPOUNDS FOR REJUVENATION

The *Cikitsāsthāna* chapters of the *Caraka Saṁhitā* recommend the following elements and compounds for rejuvenation or *Rasāyana*. These are categorised under four heads:

Abhayamalakiya Rasāyana

Brāhmarasāyanam
IInd *Brāhmarasāyanam*
Cyawanaprāśa, which is very popular and readily available
Four compounds for *Rasāyana*
Harītakyādi yoga

Prāṇakāmīya Rasāyana

This category of *Rasāyana* is meant for longevity. It includes:
Āmalakaghṛta
Āmalaka cūrṇa
Vidaṅgavaleha
Āmalakāvaleha
Nāgabalārasāyanam
Bhallātakakaśaram
Bhallāka-kṣaudra
Bhallāka-tailam
Bhallātaka-vidhānas

Karapracitīya Rasāyana

Āmalakāyasa bramarasāyanam, used by senior scientists of yore.
Kevalāmalakarasāyana
Lauhādirasāyanam
Aindrirasāyana
Medhyasāyanāni
Pippalīrasāyanam
Pipplīvardhamānarasāyanam
Triphalārasāyanam
Śilājaturasāyana

Āyurvedasamutthānīya Rasāyana

Indroktarasāyana
Droṇiprāveśikarasāyana
Second indrokarasāyana
Ācārarasāyana (behavioural rejuvenation)

RASĀYANA DRUGS

Āyurveda prescribes many drugs for *rasayana* or rejuvenation. These are:

For loss of *balya* in childhood

Amalaki (*Emblica officinalis*)
Gudūci (*Tinospora cordifolia*)
Mulatthi (*Glycyrrhiza glabra*)
Vacā (*Acorus calamus*)

To control retardation in growth

Aśvagandha (*Withania somnifera*)
Gudūci (*Tinospora cordifolia*)
Punarnavā (*Boerhaavia difusa*)
Harītakī (*Terminalia chebula*)

To control loss of beauty

Haridra (*Curcuma longa*)
Chandana (*Santalum album*)

Mañjistha (Rubia cordifolia)
Sarivā (Ichnocarpus frutescens)

To control loss of intellect

Brahmi (Bacopa monnieri)
Vacā (Acorus calamus)
Jyotismati (Ceastrus paniculatus)

To control loss of vision

Haritaki (Terminalia chebula)
Bibhitaka (Terminalia belerica)
Āmalaki (Emblica officinalis)

To control loss of sexual hormones

Aśvagandhā (Withania somnifera)
Śatāvarī (Asparagus racemose)
Śilājatu (mineral ore)

21

VĀJĪKARṆA TANTRA: APHRODISIACS

This branch of Āyurveda has been successfully established and is popular among people. The *Caraka Saṃhitā* in *Cikitsitsāsthana* has given a very elaborate definition of *vājīkaraṇa tantra* or aphrodisiacs for people on the lookout for an enhanced sexual experience. The Āyurvedic drugs prescribed for this purpose have an immediate effect in helping the individual. These drugs do not cause any harmful effects and are generally used by males. They increase the semen content and can help increase the longevity of the individual as well.

BRANCHES OF *VĀJĪKARṆA*

Like *rasāyana*, *vājīkarṇa* is also divided into four parts.

Samyogaśaramūlīya vājīkaraṇa

Samyogaśaramūlīya vājīkaraṇa believes that love resides in women. Since women are responsible for the birth of a child, it is in a woman that virtue, wealth and sex reside. Domestic life is also blessed because of the woman. Woman is the first cause for *vājīkaraṇa* (copulation). Āyurveda has enumerated

various qualities of women, which are essential to give sexual enjoyment to men as well as to enhance the chances of childbirth. This therapy thus focuses on enhancing the qualities of women. The following drugs are recommended by *Caraka Saṁhitā*:

Bṛhaṇi guḍikā
Vājīkaraṇa ghṛtam
Vājīkaraṇa piṇḍarasāḥ
Vṛṣyamāhiṣarasāḥ
Vṛṣyam catakamaṁsam
Vṛṣamaṣa yogaḥ
Naktraretobhṛṣṭam kukkuṭa-maṁsam
Aṇḍarasa

Āsiktakṣīrīya vājīkaraṇa

Following compounds are recommended for attraction and allurement, leading to sexual intercourse:

Ṣaṣṭikādi guḍikā
Vṛṣyabhakṣyā
Apatyakara swarasaḥ
Vṛṣya kśiram
Vṛṣya ghṛtam
Dadhisara prayoga

Māṣaparṇabhṛtīya vājīkaraṇa

Following preparations are included:

Vṛṣyagavya dugdham
Vṛṣyakṣīraprayoga
Apatyakarakṣīra yoga
Śatāvarī ghṛtam
Vṛṣya pāyasa
Madhuka yoga

Pumāñjātabalādika vājīkaraṇa

The following preparations are recommended for conception:

Vṛṣya vastaya
Māṁsa gudikā
Māhiṣarasa
Matsyamāṁsāni
Pupalikā yoga
Māṣādipūpalikā
Vṛṣya yoga
Apatyakaram ghṛtam
Vṛṣya-guṭika

It is said that food that is sweet, unctuous, nutritious and rich, and generally generates happiness in individuals; it is an aphrodisiac. There is a relationship between sexual enjoyment and a woman's age, selection of the appropriate mate for conception and the causes for loss of semen in men. These are highlighted in this section.

The last couplet of the *Caraka* explains and defines *vājīkaraṇa* acquired through food, behaviour and drugs.

Yena nārīṣu sāmarthyam vājivallabhate naraḥ
Vrajeccābhyadhika yena vājīkaraṇameva tat ‖50‖
—*Caraka Saṁhitā* Ci 2; 50

"The process, by which the man is capable of performing sexual intercourse like horse with women many times with force, is called *vājīkaraṇa*."

22

IMMUNITY:
THE ĀYURVEDIC VIEW

Immunity is the inherent capability of an individual to protect himself from inner disturbances and diseases. Some individuals have a weak preventive mechanism. This is a natural deficiency, which needs outside agents to supplement it. The first reason for a weak defensive mechanism is stated to be intentional violation of social regulations, such as unequal distribution of wealth, greed and other social vices. It has been termed as *prajñāparadha*, or failure of judgement. The second cause is called *asātamyendriyārtha saṁyoga* (hyper, hypo and perverse correlations of objects with special senses). The third cause includes environmental factors like: seasonal imbalances, harmful fluctuation of weather, rain, cold, heat, epidemics and endemics. It is called *parināma*.

STRENGTH (*BALA*)

Strength of an individual and society is the basis of sound health. It is an internal factor, i.e. endogenous factor. Strength is of three types: (a) bodily strength, (b) psychic strength, and (c) spiritual strength. These three in conjunction are

responsible for maintaining health and curing diseases. The therapeutic and dietetic measures or other steps are effective only through these three types of strength.

Bala or inner strength has been categorised into three types, depending upon whether it develops naturally or is acquired. These are:

Sahaja bala: It is due to innate or inherent stamina acquired by the individual naturally.

Yuktikṛta bala: It is acquired through a rational way of life, for example, through judicious use of external factors such as food, medicine, exercise, rest and conduct.

Kālakṛta bala: This kind of strength is attained at a suitable period of one's life through wisdom.

Āyurveda has further defined inner strength as the capacity of the tissues to grow and withstand physical hardship, stress and duress of hunger, thirst, heat, cold and the capacity to face intense disease. When tissues remain fresh and compact in spite of advancing age, it means the tissues are delaying the degenerative changes, which usually occur as a natural consequence with passage of time.

Āyurveda describes that *ojas*—the final product of body-building substances is responsible for different forms of energies. So, *bala* comes from *ojas*. In order to understand *ojas*, various synonyms or similies are given. These are *bala* (strength), *prāṇa* (vital energy), *urjā* (power in the form of heat), *śakti* (capacity to perform difficult actions), *tejas* (embodiment of radiant power), *sāra* (final essence), *sattva* (sublimate), *rasa* (taste), *shleshma* (having the properties of *apa* and *pṛthvi mahābhūta*). *Ojas* is like nectar in flowers and fat in milk: invisible, diffused and uniformly distributed in the body. It imparts strength, builds the constitution and capability of tissues and mental set-up.

Ojas are measured in volume in units of handful (*añjali*) and eight drops. It is a sublime form of *kapha*. It provides nutrition to the tissues for their gratification (*puraṇa*). It has the power to maintain a dynamic equilibrium and protect the embryo. It resides in the heart when the heart is formed

in the foetus. It remains there to supply the heart with strength to beat ceaselessly. Its loss leads to death.

Bala also means *agni*. All diseases are the products of deficiency or derangement of *agni*. *Bala* is also formed by balanced and unprovoked *vāta*. Without *vāta* (nervous system), there is no activity. So, the vital energy is *vāta* and its strength comes from *ojas*. Food is also *prāṇa* or life taken from outside. So food is also *bala* (strength) or a source of strength.

Bala also resides in the mind and helps endure various types of stresses and traumas. These can be classified into three groups. The first group is *prawara-sattva*. These individuals have the highest power of enduring torture and pain. Second is *madhya-sattva*, i.e. medium endurance capacity. These individuals have the courage and moral strength only after being inspired by other persons. The third is *avara-sattva* or *heena-sattva*. This type of person has the lowest capacity or no capacity to bear any distress. These three types of *bala* work at different levels that include:

- At the level of physique
- In the sphere of psyche
- In the sphere of *agni*
- Special level in women

It imparts the fair sex their figure, softness, complexion, and sweet musical voice and youthfulness even in old age.

In modern parlance, the *ojas* connotes psycho-neurotic immunity, pituitary hormones, growth promoting hormones, and lactogenic, thyrotropic, adrenotropic, gonadotropic hormones.

LOSS OF *BALA*

There are various causes for loss of *bala*. These are:

- Natural causes such as weak constitution, lack of superior *bala*, having low strength genetically.
- Virulent diseases and extreme psychosomatic disorders.

- Poor nutrition.
- Lack of proper care while growing up.
- Over-exertion and worry.
- Lack of proper rest and sleep.
- Over-indulgence in sex without proper nourishment.
- Diseases causing excessive loss of body fluids.
- Invasion of dangerous influences of plants, *bhūtas*.

STEPS TO INCREASE AND MAINTAIN *BALA*

- Proper drugs and diet.
- Protecting the body from loss of *bala* through any channel.
- Special care to be taken to prevent diseases like diarrhoea, bleeding, polyurea, diabetes, burns, etc.
- Avoiding irrational exertion, excessive worry and anxiety.
- Sudden mental shock severe grief due to death of near ones.

DRUGS

Ojas- or *bala*- promoting drugs are prescribed under different categories. These are as follows:

- *Rasayana* – promoting health, longevity and strength
- *Jeevaneeya* – life-protecting drugs
- *Bṛhaniya* – tissue-building drugs
- *Balya* – imparting strength and power
- *Madhura* – drugs having sweet taste
- *Sonitasthapana* – preventing loss of blood

Drugs prescribed by authentic authorities are well known in routine Āyurvedic practice for the prevention of disease and promotion of health. These drugs are credited with the property of building up internal resistance (*bala*) against chronic accumulation of toxins, as well as protecting the vital organs.

23

SPIRITUALISM AND ĀYURVEDA

Āyurvedic treatment takes its theories from both the materialistic and the spiritual world. It is a purely integrated course where the valuable concepts of God and devotion are explained in the context of the human body.

Āyurveda not only deals with the physical body, but also describes a complete human being or *puruṣa*. All diets, herbs, lifestyles or exercises described in Āyurveda refer to the complete *puruṣa*. The word *puruṣa* was used in the *Vedas* to mean Ultimate Reality. This *puruṣa* desired to become many. So, multiple *puruṣas* came into existence. These evolved *puruṣas* were called *bhūtāni*.

Epistemologically, the evolved *puruṣa* from unmanifested entity was considered to be composed of six elements — five primordial evolved entities and consciousness. The newly evolved *puruṣas* or *bhūtāni*, however, was made of 24 elements and one conscious entity.

Subsequently, the existence of mind was proved. The mind is responsible for thinking, consideration, ambition, hypothesis, attention, determination, etc. Control of sensory organs, self-restraint and so on are also actions of the mind. Beyond this flourishes the domain of intellect (*buddhi*). *Puruṣa*

is influenced by *rajas* (activity) and *tamas* (inertia). When these influences are removed, the mind becomes free by virtue of the dominance of *sattva*.

Evolution in man is complete with the combination of 24 elements — cause of action, fruit of action, knowledge, ignorance, happiness, misery, life, death and ownership, etc. One who is really conscious of these effects in the form of life and death, in origin and destruction of the universe, as well as continuity of the existence, constitue the true *puruṣa*. The conscious entity also knows all knowable objects.

It is further explained that the evolved *puruṣa* gets involved with other objects and actions. He is responsible for ego, enjoyment of fruits of action, engagement in action, transmigration and memory of the individual. The *Caraka Saṁhitā* has clarified the difference between the *puruṣa* (Ultimate Reality) in the beginning and evolved *puruṣa* (*bhutani*) at the end. The supreme soul does not take birth like that of the *bhutani*. The supreme soul or Ultimate Reality has been termed as *paramātmanaḥ*. The evolved *puruṣa* has been termed *rāśi puruṣa*, who is a combination of 24 evolved elements and conscious entity.

Existence of the universe and its objects are due to *paramātmanaḥ*. The mind and the body together with the sensory organs excluding hair, tip of the nail, ingested food, excretory matter and objects of senses are the sites of manifestation of happiness and miseries.

Āyurveda is concerned with union (*yoga*) to form *rāśi puruṣa*. But, the *yoga* in the context of liberation implies techniques used to control sensations by concentration. It is stated that happiness and miseries are felt due to the union of soul, the sense organs, mind and the object of senses. If all the four are together, only then can we understand happiness and pain. Both misery and happiness do not cause any effect on the mind when the mind is concentrating and under the control of the soul. This stage of concentration generates supernatural powers in the mind and body, and is known as *yoga* according to sages, who were well-versed in the control of mental faculties.

There are eight supernatural powers of the *puruṣas* who practise yoga. These are:

- Entering others' bodies
- Reading others' thoughts
- Doing things at will
- Supernatural vision
- Exceptional hearing
- Miraculous memory
- Unusual brilliance
- Invisibility when desired

These super powers are subjects of further research. But, experts who have control over their body, mind and senses, have experienced these. It is very essential to enumerate the concept of *puruṣa* as conceived by Suśruta.

Puruṣa is used in the *Vedas* to mean invisible, i.e. *avyakta*. *Suśruta Saṁhitā* says that an invisible entity has no cause but he is cause of *jagata* or the created world. Both Nature and *puruṣa* are eternal, without end or beginning; both are indestructible; both are without form; both are equally superior; both are capable of moving in all directions. The only differences are in respect of consciousness and unconsciousness. Nature is not conscious. Nature has four qualities: (1) happiness, (2) unhappiness, (3) lust, and (4) *sattva, rajas,* or *tamas* qualities. There are many *puruṣas* who may be conscious and without characteristics.

In essence, all creations can be attributed to *bhūtāni* (evolved entities). Also, cause and effect will not differ in signs and nature. Therefore, the characteristics of evolved entities will be reflected when these act as cause/causes. So, all effects, including causes, constitute the place of various activities like a village. Just as villagers perform their routine tasks or their allotted functions, so also, evolved entities reside at one place and do their functions. This place is called *bhūtagrāma*.

Due to results of good or bad deeds, the soul gets appropriate *bhūtagrāma*. There are three types of births depending upon the type of individuals. The soul can either

manifest as human body, a celestial body or no body of any significance. The last is meant for bad souls or devils. The soul is very small (*anu*), eternal, and knows the body of his occupancy.

After the union of the body and soul, the individual is considered to be receiving fruits of his/her deeds. Besides, the union of soul with mind generates happiness, unhappiness, desire, hatred, trial, respiration, discharge of excreta, closing and opening of eyes, intellect, determination of mind, thoughts, remembrance, science, definite wisdom and knowledge of perceived themes. These six properties, come about when the soul unites with the mind.

MAN AND HIS MIND

The concept of mind is extremely important and significant in Āyurveda. Diseases are classified into two categories: physical and mental. As the mind plays a vital role in the ultimate outcome of any effort or effect, and combination of both is termed as the psychosomatic effect. Actually, the mind affects bodily functions in the same way as the body affects the mind. So, it is advisable to take psychic measures even in bodily diseases. Āyurveda has taken both into account while prescribing treatments.

The union of the mind (*manas*) with the soul or *puruṣa* generates many faculties based on *samayoga*. Neither *ayoga* (no union) nor *mithayayoga* (false union) should be established. This branch of proper use of mind was dealt by Patanjali's *Yoga Sūtra*. There are different schools of *yoga* and they have prescribed different methods. But all of them stress the utility and control of faculties of the mind (*citta*) and prescribe various methodologies to realise oneself. There are four basic parts of *yoga*: (1) *samādhi* (trance), (2) *sādhanā* (means), (3) *vibhūti* (powers) and (4) *kaivalya* (absoluteness). The recitation of *mantra*, i.e. control of mind, maintenance of physical posture (*āsana*) for physical fitness and health, and breathing exercises (*prāṇāyāma*) generates good qualities.

Rules and regulations (*yama* and *niyama*) for preparing oneself for a yogic discipline, adhering to a scheduled diet, observing fasts and rituals as well as aberrations so that a *yogi* can attain perfection of body, mind and soul are essential.

SYNONYMS AND THEIR SIGNIFICANCES

Manas has five important synonyms, viz. (1) *citta*, (2) *caita*, (3) *hṛdaya*, (4) *svānta* and (5) *hṛt.* The term *manas* is derived from the word '*man*', which means to think. Thus, it is a faculty responsible for the phenomenon of thinking. Actually, the meanings and significances are judged in accordance with their context. For example, *hṛdaya* and *hṛt* mean 'centre' or 'the heart which appears to be the seat of the mind'. *Citta*, mind (*mana*), ego (*ahaṁkāra*) and intellect (*buddhi*) are means of perception. So, *manas* along with its synonyms conveys different aspects and attributes of the same entity.

The Mind and *Manas*

The English equivalent of term *manas* is mind. The term has been used extensively. So, it attains different conceptions in various visionary discourses. Western philosophy has also contributed to the psychological meaning and significances of this word, i.e. mind.

The *Riga Veda* and *Yajurveda* have described the nature and function of the mind. The *Upaniṣads* had tried to give precise form and substance to the term and its epitomology. In the later works of visionary discourses of Buddha and Jaina *darśanas*, the term *manas* was explained systematically. Psychological independence was a subject of its own. In Āyurveda, it was treated with the body and is said to come out of *avyakta* by an evolutionary process.

Psychological discourses in three visionary schools of knowledge gave a mechanistic view. It is said that the mind is of atomic size and one in number. It is only a connecting link between the soul and the sensory organs and is instrumental in the generation of knowledge. It has no special property

like colour and so on. The above view is projected in the works of many thinkers such as Gautama's *Nyāya*, Kanāda's *Vaiśesika* and the *Mimāmsā Darśanas.*

Kapila's *Sāmkhya*, Pātāñjali's *Yoga* and the *Vedānta Darśanas* propounded the psychic view of the mind. According to these, *mana* attains the size as per the object it perceives and is transparent. It appears to be a conscious entity due to its contact with consciousness, the soul. They consider *mana* to be psychic in nature and having three different qualities, i.e. *sattava, rajas* and *tamas*, that are responsible for proper development of the self. These include the power of comprehension, functioning and inertia, respectively.

Logical thinking concludes that the soul is conscious, so the mind is also conscious because of its close link with the soul. The degree of consciousness also becomes a relative term. It is believed that all elements of Mendeleyev's periodic table are available in every cubic metre of rock if only our method of detection works with accuracy. The progress of science depends upon finding new methods to evaluate existing facts, data and substances in the finest of details. Accumulation and disintegration of certain elements indicate the functioning of the metabolic process at a very slow rate. Similarly, reaction to certain forms of stimuli may not be obvious, but the time may come when scientists would register the reaction of stimuli of everything, including rocks, with the help of supersensitive instruments. There are two valid reasons to put forward the sensitivity of every particle: (1) the movement of electrons in the atoms, and (2) presence of Creator in each and every item.

INNER PERCEPTION

Sensations are recorded within the appropriate sensory organs. The ears receive sound, touch is felt by the skin, the eyes are responsible for vision, taste is detected by the tongue, and various odours are sensed by the nose. These sensations, recorded externally, are transmitted to the inner means of

receiving perceptions and are received by extra-sensory organs called *ati-indriyas.*

External sense organs are a means of receiving sensations; the inner means of perception are the real sensory organs. These organs are further classified into four types: (1) *manas,* (2) *citta,* (3) *buddhi,* (4) *ahaṁkāra.* The heart and brain are both considered to be interconnected with the mind and their functions are interdependent on each other. While Āyurvedic texts are in favour of allotting the heart as the seat of mind, the yogic school considers the heart and brain to be the seats of *manas.* The subject of *Naḍi Vijñāna* is very important in realisation of inner power of the self. *Iṭā* (*Piṅgala*) and *suṣumṇa* in the spinal cord are explained in detail in *Naḍi Vijñana* for achieving various levels of consciousness. The *kuṇḍalinī śakti* or dormant/latent energy is said to be like a sleeping serpent and is located in the last portion of spinal cord. The technique of awakening this dormant power is known by the yogic experts.

These powers are exhibited by *yogis* and have been described in yogic texts. When these powers are aroused, it is said to create a tremendous influence on the mind of the person and the mental faculties become extremely active and powerful. This means that the yogic technique involves the heart, the brain and the spinal cord, including the two sympathetic channels. Hence, all these parts of the body can be considered as seats of the mind or as possessing psychic powers.

It is also stated that Āyurveda considers the mind as a micro-organism. It is considered to do only one function at a time. The nine *dravyas* (nine conceived substances where actions and attributes find shelter) are:

- *Ātmā*
- *Manas*
- *Diśā*
- *Kāla*
- Five *mahābhūtas* described in *Nyāya* and *Vaiśeṣika* schools of Āyurveda

These are constituents of the universe. There is another school of thought which considers non-existence, i.e. *abhāva* as the tenth constituent of *dravyas*. The *Sāṁkhya* and *Yoga* schools state that the five sensory organs, the five motor organs and the mind are created by *sattvika* and *rajasika* aspects of the ego (*ahaṁkara*).

DIFFERENT LEVELS OF THE MIND

Different levels of the mind constitute the disposition of the individual. These levels are tempered by three attributes of the mind — *sattva, rajas* and *tamas*. There are five levels of the mind:

- *Kṣipta:* Disturbed; the mind is greatly attracted by the objects of senses
- *Mūḍha:* Foolishness, stupidity, ignorance infatuation, idiocy
- *Vikṣipta:* Distraction
- *Ekagṛtā:* Concentration
- *Niruddha:* Cessation of mental faculties; the mind becomes calm and tranquil

CLASSIFICATION OF MENTAL FACULTIES

It has been explained that there are three types of mental faculties, namely *sāttvika, rājasika* and *tāmasika*. *Sāttvika* quality of mind is superior to the other two types. It is auspicious, pure and pious. The *rājasika* type symbolises royal dignity, is dynamic in nature and active. *Tāmasika* type suffers from ignorance. There are, in fact, innumerable types of mental attitudes with various permutations and combinations of the faculties. The psychic nature affects physical nature and vice versa. There are seven categories of *sāttvika*, six of *rājasika* and three of *tāmasika*. Their natures are described and compared with similies of the gods, other celestial beings, animals and plants. Broadly they can be described as follows:

Sāttvika Type of Mental Faculty

1. *Brāhma* **(possessing characteristics of Lord Brahmā)**
 - Purity, love for righteous qualities over self.
 - Knowledge of matter and power to analyse.
 - Power of expression, remembrance and reply.
 - Freedom from passion, anger, blindness, jealousy, tension and depression.
 - Love and affection for all living beings.

2. *Ārṣa* **(sharing the traits of classical personality)**
 - Devotional action and performance of oblation and bachelorhood.
 - Generous nature.
 - Lack of ego, pride and hatred.
 - Intellectual superiority and oratory skills.

3. *Aindra* **(having characteristics of Indra)**
 - Lordship, king-like behaviour.
 - Doing acts of sacred rituals.
 - Vigour, power.
 - Devoid of lower action.
 - Far-sightedness.
 - Attachment to luxurious items of life, positive achievements.

4. *Yāmya* **(personality like Yama)**
 - Punctuality.
 - Observing of rules and regulations.
 - Preparedness for action.
 - Memory and authority.
 - Devoid of mean mentality and anger.

5. *Varuṇa* **(behaving like Varuṇa)**
 - Purity, courage and patience.
 - Obeying and following religious rites.
 - Dislike for mean acts.
 - Timely expression of inner feelings.

6. *Kauvera* **(characteristics of Kauvera)**
 - Owner of luxuries, riches and financial control.
 - Love for good deeds, wealth, etc.
 - Purity.
 - Love to create and enjoy.

7. *Gandharva* (characteristics of Gandharva)
 * Love for fine arts.
 * Fondness for dance, music, etc.
 * Recitation of poetry, history and epics.
 * Association of women wearing fine clothes.

Rājasika Type of Mental Faculty

1. *Asura* (traits of an *āsura*)
 * Bravery.
 * Cruelty.
 * Envy.
 * Evil appearance.
 * Ruthlessness.
2. *Rākṣasa* (having traits of the devil)
 * Lack of tolerance, gluttonous, love of non-vegetarian food.
 * Excessive sleep and indolence.
 * Jealousy.
3. *Paiśāca* (having nature like *paiśāca*)
 * Eating excessively.
 * Lacking in cleanliness.
 * Love for women.
 * Cowardice.
4. *Sārpa* (having nature like snake)
 * Revengeful nature when disturbed.
 * Fearful nature.
 * Increased reflex reaction.
 * Excessive indulgence.
 * Afraid of external environment.
5. *Praita* (sharing qualities of *preta*)
 * Gluttony.
 * Suffering from previous bad deeds.
 * Envy.
 * Inactive attitude.
6. *Śākuna* (having traits of *Śakuni*, the bird)
 * Attachment to feelings, liking for excessive food, unsteadiness, revengeful nature.
 * *Tāmasika* type of mental faculty.

7. *Pāśava* (**character of an animal**)
 - Lack of intellect.
 - Hateful conduct.
 - Forbidding disposition.
 - Indulgence in excessive sexual acts and sleep.
8. *Mātsya* (**character like a fish**)
 - Fearful, fondness for food, unsteadiness, passionate.
 - Fondness for constant movement and desire for water.
9. *Vānaspatya* (**character of vegetable life**)
 - Indolence.
 - Lack of mental faculties.

SALVATION

Spiritualism, as propounded by Āyurveda in *Caraka Saṁhitā* leads to acquisition of supernatural powers as also absolute detachment from worldly life by virtue of absence of *rajas* and *tamas* in the mind and destroying the effects of potent past actions. This detachment does not generate any more bondage for creating birth and then death in a continuous circle. There are some means to break this vicious circle for attainment of salvation (*mokṣa*). These are as follows:

- Association with noble souls.
- Avoid association with the wicked.
- Observing desired vows and fast.
- Pursuit of the rules of good conduct which lead to salvation.
- Compliance with treatises that indicate duties and responsibilities.
- Knowing scientific and technological methodologies.
- Liking for solitary existence.
- Detachment from objects of the senses.
- Striving for *mokṣa* (salvation).
- Professional control over intellect and mental faculties.
- Avoiding acts that lead towards good as well as sinful effects.

- Destroying effects of past actions.
- Desire to be away from the worldly trap.
- Absence of egoistic disposition.
- Being afraid of contact of the soul, mind and the body with worldly objects.
- Concentration of mind while taking possession of soul.
- Reviewing spiritual facts.

It has to be recognised that both the body and soul are separate entities deserving merit. The above actions have to be performed by the two permanently, so that one may rise above happiness as well as sorrow.

Caraka Saṃhitā at *Śārirasthana* advocates eight factors for a good memory:

- Knowing the cause.
- Knowing the form.
- Knowing similarity.
- Knowing contrast, i.e. knowledge of light cannot be appreciated without knowing darkness.
- Concentration of mind.
- Repetition.
- Attainment of power of experience in seen and heard things.
- Union with knowledge.

Memory is to remember things directly perceived, heard or experienced earlier. Persons following the path of remembrance do not come back to be entrapped by ignorance. It is a way of union with the Ultimate Reality and Truth. Therefore, this is a real *yoga* as well as *mokṣa*.

24

THE ROAD AHEAD

Living beings have got natural powers to prevent diseases caused by micro-organisms. At present, animals in underdeveloped and developing countries exhibit more power than human beings. In ancient times, this power was known to human beings too, as their immunity was stronger than what is seen today.

Modern civilisation has generated many harmful devices and destructive atomic explosions, which have lowered the psycho-neuro-immunology. Cognitive centres and limbic emotional centres receive unhealthy stimuli, which do not support the immune system. The autonomic nervous system sends unhealthy signals to the bone marrow, thymus, spleen and mucosal surfaces where immune cells develop, and encounter foreign proteins. The chemical messages have degenerated the immune tissue.

Stress and strain of modern civilisation are the causes for release of inflammatory messages. The nervous system and inflammatory cells change their functions as per the reactions between them. Similarly, hormones production by the hypothalamus and pituitary gland regulate the function of other glands in the body. These are also capable of bringing

a change in every type of immune cell. The surface receptors of immune cells are capable of receiving hormones of all types, including growth hormone, thyroid stimulating hormone, sex hormone and many other hormones produced by endocrine glands. Besides, the immune cells have receptors for natural endorphins and encephalin produced by the brain. These affect the immune system function. Some are helpful and some cause suppression of the immune system.

Feelings, emotions, thoughts, behaviour and diet affect this complex system of the brain and the body. Each player involved acts on other players who influence it. These players do not play positively, so corrective measures are needed to maintain a dynamic equilibrium within the congregated person (*rāśi puruṣa*). This process of constant correction and regulation has weakened the immune system while following symptomatic and anti-micro-organic treatment. This has been going on with human beings for the last one hundred years or more. Pathological changes demand surgical intervention. So, many new techniques have been evolved to cover up the failure of internal medicine in respect of strengthening the immune systems.

Health for all remains a distant reality. Communicable and non-communicable diseases have appeared in new forms: some are caused by water-borne infections, respiratory tract infections, etc. Tuberculosis, HIV/AIDS, Severe Acute Respiratory Syndrome (SARS) and psychosomatic diseases have become serious problems to the world health authorities in general and the developing countries of the world, in particular. Dr Carlos Urbani, conducting research at WHO's Hanoi centre, diagnosed the mysterious disease called SARS and became the victim of the dreadful disease.

Combating these micro-organisms is not confined to one part of the world. These airborne, sexually transmitted and other infections are a source of concern for all countries. It is an alarming danger to health authorities and administrators. Immediate remedies are to be adopted. The answer to these diseases is to build psychoneurotic immunology (*Rasāyana*

Cikitsā) as explained and described in Āyurveda. Its importance and significance have already been highlighted by giving a brief account of various aspects of Āyurveda. Revival of Āyurveda is the survival of humanity as well as liberation from sufferings, wants, socio-economic imbalances and political upheavals due to unhealthy set-ups.

Āyurveda is the ultimate medicine whose time has come to serve and solve all type of maladies.

GLOSSARY

Agama: unattainable, inaccessible
Agni: fire
Apya: water
Āptavacana: saying of sage
Asambhava: not possible
Ativyāpti: excessive application, covering many articles
Ātmā: Soul
Avyakta: invisible
Avapti: not applicable
Ayana: the sun's course either north or south of the equator,
 equinoxial point
Buddhi: intellect
Buddhātma: awakened soul, enlightened soul,
 knowledgeable soul
Bhūta: one of the primordial elements, past time, devil
Caraka Saṁhitā: one of the classical treatises of Āyurveda
Dakṣiṇāyana: southerly course of sun at summer solstice from
 the Tropic of Cancer
Darśana: visualised basic discourse covering also philosophy,
 metaphysics and science
Deva: a deity, a respectable person, god

Dhairya: fortitude, steadiness

Dravya: substance

Gandha: smell, fragrance, aroma

Guṇa: quality, properties of matter

Indrayārthas: objects of organs

Jala: water

Jñāna: knowledge

Kāla: time, climate, time of death

Kapha doṣā: supportive/vitiating element representing subtle primodial matter of water and earth

Kāraṇa: cause

Kāya: the entire body

Kāya Cikitsā: internal medicine

Kārya: effect

Loka: visible universe

Manah: psyche or mind

Pitta doṣā: digestive or metabolic system

Pañcamahābhūtas or *Pañcabhūtas:* five subtle primordial elements

Pitta: supportive/vitiating functional represenstive of fire (teja)

Prabhāva: unexplained effect

Pramāna: true recognition

Prakṛti: nature

Pratyakṣa: direct observation, visible assessment

Pṛthvi: earth

Purvavat: similar to earlier ones, infer effect from cause

Rasa: taste, mercury

Rūpa: form, shape

Śabda: word, sound

Sahaja buddhi: natural intellect

Samādhi: concentrated presence before the truth

Sāmānya: common, similar

Samavāya: concomitance (logic) collection, multitude

Samānyatodṛṣṭā: infer both cause and effect at the same time

Samayoga: balanced union

Śarira: body, catabolic processes of the body

Śāstra: treatise

Śeṣavat: infer cause from effect

Sparśa: touch

Śruti: heard discourse

Śmrti: remembered discourse

Sūtra: concise definition, aphorism, thread

Tantra-māntra: formula/formulae based on the system of discipline

Tridoṣas: three functional representatives of five subtle primordial elements conceived through epistemology

Upamāna: that with which some thing is compared

Uttarayāna: northerly course of sun at winter solstice from the Tropic of Cancer

Vijñana: science

Vipāka: metabolites

Vinayikic buddhi: intellect of Gaṇeśa or god Vinayaka

Virya: potency of substance (dravya)

Viṣamāgni: irregular/uneven metabolic processes

Viśeṣa: special

Vāta doṣā: supportive/vitiating functual representative of *ākāśa* (space) and *vāyu* (air) subtle primordial elements conceived through epistemology

Vyakta: visible

Yukti: reasoning